mondrian

Italo Tomassoni

Hamlyn

London New York Sydney Toronto

twentieth-century masters
General editors: H. L. Jaffé and A. Busignani

© Copyright in the text Sadea/Sansoni, Florence, 1969
© Copyright this edition The Hamlyn Publishing Group Limited 1970
London · New York · Sydney · Toronto
Hamlyn House, Feltham, Middlesex, England
ISBN 0 600 35925 5

Colour lithography: Zincotipia Moderna, Florence
Printing and binding: Cox & Wyman Limited
London, Fakenham and Reading

Distributed in the United States of America by Crown Publishers Inc.

mondrian

contents

List of colour illustrations

List of black-and-white illustrations

Pure abstraction

In European art during the early years of this century the non-figurative movements, such as Constructivism, Suprematism, Neoplasticism and the Bauhaus, which were concerned with pure abstraction, had as a common denominator a rigorous formal rationalism. Their fundamental intention was to translate into visual terms the rational consciousness of the world, so that form should express the logic of the hidden structure of reality.

Since the desire to reduce human experience to a rational order, which is historical order conceived from an ideological viewpoint, implies a moral attitude, the aesthetic aspect of these movements is indissolubly linked to an ethical order which, in the modern world, must have reference to the sphere of social function.

It is for this reason that, beginning with the critical spirit of the Enlightenment, an ideal of an earthly society organised on a scientific and technological basis has taken the place of the metaphysics of the Middle Ages, the idealism of the Renaissance and the dramatic spirit of the Baroque era. This new concept of the world was codified in the absolute and 'concrete' rationalism of pure plastic abstraction, the visual system which corresponded most closely to its lucid and harmonious view of historical order. To a large extent the origins of this cultural system are to be found in the new plastic order delineated by Piet Mondrian, who inspired and developed the principles of De Stijl, the most rigorous and theoretical of all the abstract movements.

The systematic search for the style (De Stijl) which would epitomise the epoch (the 'idea of the age' in which the individual disappears) documents the overcoming of personality by the autonomy of the work itself, the dissolving of the individual in the collective. De Stijl proposed a new kind of relationship between man and reality, involving the abolition of all personal or subjective tendencies in the immutability and precision of a logic which can be demonstrated on the level of the rational universe of geometry. Mondrian established the most representative reflection of the image of the twentieth-century world which he was to symbolise, and which was to recognise itself in him according to a reciprocal process. He himself defined this process in the first number of *De Stijl* magazine: 'It is the spirit of the times that determines artistic expression, which in turn, reflects the spirit of the times.'

While a declining culture was opposing its desperate and profound romanticism to the utilitarian perfectionism of the positivists, challenging technology and industrial civilisation in the name of lyrical expression and the revolt of the individual, De Stijl fought for a rational consciousness which was to be achieved in the field of art, finding its logical principle in

The principles and premises of De Stijl

the clarity of style. It understood that technological values could no longer be excluded, and that the old conflicts–those between the individual and the collective, artistic activity and industrial techniques, freedom and control, the individual and the environment–had to be resolved; that instead of emphasising their separateness it was now necessary to unite them.

Technology can, no doubt, have negative results, and it is possible to attribute to these the separation between art and life in the contemporary world. But if technical knowledge and science are facts of the contemporary consciousness, they must be included in any concept of a historical rationalism. Only an art which takes these factors into consideration and bases itself positively on them will succeed in recomposing human experience into a higher harmonic order, by first of all treating art itself as the essence of experience. Thus, in the De Stijl concept, art is not differentiated from life.

De Stijl held that since ethical questions are resolved in art, and art is resolved in social life, artistic activity would no longer be the highest target of mankind, but a means for the further development of humanity. Aesthetic research, like any other human activity, would be the result of a continuous, direct contact between the artist and the world, rather than the fruit of material or spiritual exile. Mondrian himself elaborated the pure crystal of his theorem in the very heart of the world: in Paris, in London, and in New York. These cities, representing the final overthrow of the natural 'picturesque' and 'sublime' and the victory of human will over nature, indicate as the irreversible condition of contemporary man not a utopian, out-of-date, stationary state of nature, but a new culture integrated with society and progress.

In this sense the basis of Neoplasticism and De Stijl was 'political' and social: it sprang not from an ostentatious 'ideological' activism involved in the particular problems of a particular group (we remember the ironic appraisals of De Stijl in the 'Internationals'), but from the need for a fundamental morality which, from within, should form the consciousness of man in society, with reference to the condition of collective life.

In this also De Stijl shows itself to be consistent. It would be unreasonable to pretend an 'ideological' commitment for a movement which, since it deliberately abstracted itself from the contingent world, could not share any ideology except the utopian one of an ideological absolute. Although the community theoretically envisaged by De Stijl can be described as utopian (of course a utopia can only exist as such in the mind), so that it could never succeed as a means for collective salvation, its standards undeniably provided working rules for the conduct of life, and constant critical alternatives to the *status quo*. The aim was to make the whole of life into a complete aesthetic action, when it would become 'truly human', that is, completely moral. When that point was reached, art as a separate entity would cease to exist.

In the name of this new assessment, or devaluation, of art, De Stijl proposed its absorption into a new, non-esoteric dimension beyond specific artistic activity. It opposed, with its constructive reasoning and its lucid indifference to the particular, both the individual commitment of the Romantics and the destructive nihilism of Dada. For the emotional sublimation of the 'decadents' it substituted the formative processes of the 'economic, functional and social' architecture of workmen's housing and town-planning projects.

When Argan wrote that 'In the formulation of De Stijl art is reduced to a minimum; the only justification for such a severe reduction is that the minimum is exactly the dose in which art can be assimilated and circulated throughout the entire body of society', and that 'Mondrian's paintings are . . . conscious deserts of poetry and beauty', this is what he meant.[1]

Mondrian and Neoplasticism Mondrian's aim was to eliminate the tragic aspect of everyday life by

1 G. C. Argan, *Studi e Note,* Rome, 1955, p. 167 ff.

8

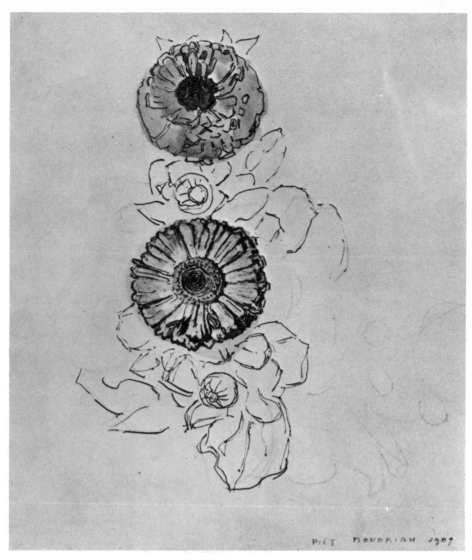

1 *Two Marigolds*
1907, watercolour
$8\frac{1}{2} \times 7\frac{1}{2}$ in (22×19 cm)
Harry Holtzman collection,
New York

abolishing the disequilibrium that exists between the individual and the universal. Since he believed that this disequilibrium originated in a false perception of reality, he proposed a visual universe that should educate the new society to see according to a purely plastic and rationally demonstrable scheme, so that experience thus visualised should be the style and rational norm of behaviour. 'The artistic temperament, the aesthetic vision, recognises style. Ordinary vision, on the other hand, does not see style either in art or in nature. This is characteristic of the man who is not able to raise himself above the sphere of the individual', wrote Mondrian in 1917. Painting, even if it is understood as meaning the representation of the world, remains an individual activity, and this explains why the form of Mondrian's work is the result of the identification of painting (essentially a perceptive activity and hence rich in psychological motivations) with architecture, which is socially orientated. This attitude is summed up in the formula 'architectonic-chromoplastics', which was realised in a concrete form by Rietveld in his Schröder House at Utrecht. The leaders of De Stijl occupied different positions within the framework of Neoplasticism. For Mondrian art was preparing the way for the universal spirit; Theo Van Doesburg believed that the decline of the aesthetic phase would be followed by human progress; Cornelis van Eesteren and J. J. P. Oud exalted engineering, technology and town-planning. In all of them every tremor of feeling or unconscious motivation was elevated by logical reasoning.

Neoplasticism is the most complete and meaningful term in Mondrian's vocabulary. In it space becomes the image of rational consciousness, the measure to which all our experience must be referred and related. The pure formal relations of his art are not the 'symbols' of a mathematical equation or a geometrical theorem, but are in themselves a geometrical-mathematical vision of the world.

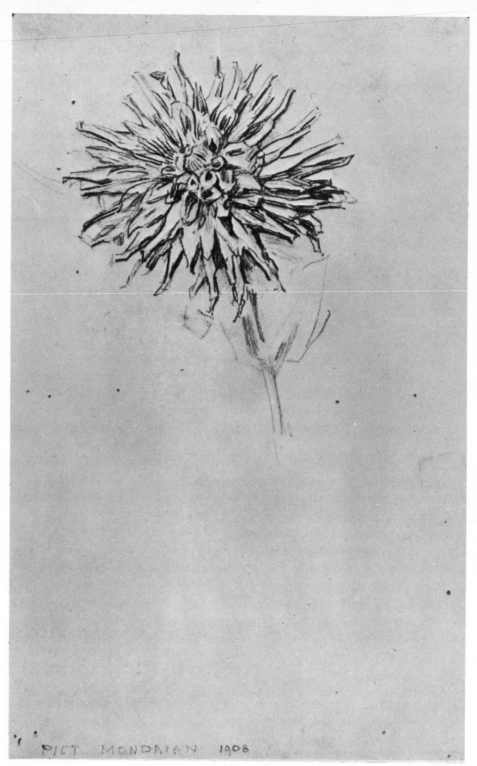

The relationship between the artist and the appearance of the world is reversed: if to represent is always to express by means of symbols, then in order to avoid the symbol it is necessary not to represent; that is to say, not to present the image as a substitute for reality, as it was in the past. In this way art will no longer be imitating life; life and experience will shape themselves according to the model of art. The value of art will be as an absolute archetype and a formative pattern in the process of integrating art and life.

Since reality changes and evolves according to the rational intervention of man, the artist will not illustrate his own vision of the world and try to impose it on others, but will trace, on a conscious level, the design of a rational and harmonious pattern of experience and creativity. 'Art goes before life,' as Mondrian puts it, by becoming a science, by revealing a new structure of the world and of consciousness, and inventing and analysing a new language to express it, explain it, and give it a form. In the 1920s the extra artistic potential of De Stijl's austere teaching was brought to life in Europe chiefly in the applied arts, that is in the arts most directly linked with

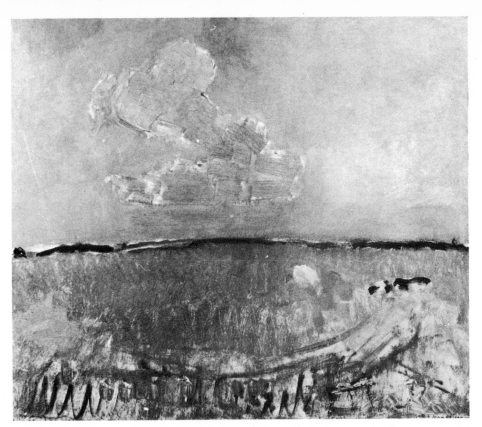

3 *The Red Cloud*
1907–9, oil on cardboard
$25 \times 29\frac{1}{2}$ in (64×75 cm)
Gemeentemuseum,
The Hague

social functions–graphics, furniture, industrial design, and of course architecture and town-planning. The applied arts are not merely to be looked at; they are to be used, their concrete function enabling them to be understood as real conditions of life and human experience.

Like the utopian socialists of the first half of the nineteenth century, the historicist architects and the Romantics, the artists of De Stijl believed that it was the task of art to sublimate and resolve social conflicts. These had been aggravated by the industrial revolution, which launched the first offensive of standard mass-production against the unique quality of artistic techniques. Art was to achieve this reconciliation through functional architecture, which could materially improve the environment by integrating spatial factors and social motivations and thereby creating new, rational patterns for living together; its solution was to lie in town-planning as the structure and guide of human behaviour in the environment.

The reformist origin of these ideas is obvious, and there is no doubt that Dutch Calvinism influenced the rejection of the natural image advocated so uncompromisingly by the Neoplasticists, who thus also inherited some of the iconoclast mysticism of the Reformation. Further and more recent sources of De Stijl's austerity can be found in a metaphysical line of thought that includes Leibnitz, Descartes, and Spinoza. The latter had sought with rigid impersonality the determination of a universal order which excluded all anthropomorphism, and in which even the human world was scrutinised with the lack of emotion with which one might study lines, angles and volumes. De Stijl, however, was not a purely metaphysical movement, in that it was deeply concerned with the relationship between art and production, as well as with a practical, secular, and contemporary concern for modern society with all its problems–social inequalities, technological dangers and scientific achievements.

These two aspects, the metaphysical and the positivist, are united by an aesthetic activity which does not, like the empirical system of the Bauhaus, separate individual creativity and collective production. Instead it achieves a harmonious equilibrium between contemplation and experience, that is the unity of reality, in the logic of its constructive methodology.

Since the conquest of this state of liberty-necessity cannot be the product of individual initiative or the result of an intuitive act, but is the outcome of collective collaboration and logical reduction, the teleological course taken

by Mondrian and the De Stijl group towards the discovery of the rules of formation and construction can be reconstructed from the evolution of themes in their work.

From reason, as the critical principle of reality, the ethical norm of behaviour is expressed through art, and the renewal of social forms depends on the renewal of forms in art. In an evolutionary ideology such as this, whose aim is civilisation, the artist, obviously, takes on the role of guide.

Neoplasticism and De Stijl

De Stijl as a movement originated at Leiden in 1917 with the founding of the review *De Stijl*, with Theo van Doesburg as its promoter, nearly four years after Mondrian had outgrown his Cubist phase.

The factor which the aesthetic exponents of De Stijl held in common was the methodology. This is the starting-point for every technique; through it human activity creates form, the basis of structure. De Stijl's methodology led to a form that was the very structure of reality and of consciousness, and so it had to be based on certain elementary principles and essentials applicable to any type of action: a spatiality of right angles and planes, a new plasticity, a 'neoplasticism'.

Neoplasticism was logically implicit in Mondrian's aesthetic evolution. This is clear from his essay *The new plastics in painting*, which was published in the first number of *De Stijl* (October 1917) and is a primary source for the theory of abstraction. 'The new plastics must find its own expression in the abstraction of all form and colour, that is in straight lines and in primary colours distinctly defined.' This is corroborated by numerous testimonies to the same effect by van Doesburg, in *De Stijl* and elsewhere. Thus although Bart van der Leck made some claims to be recognised as the originator of De Stijl, Mondrian was the real founder of the movement; it was his researches that directed its spirit and its aesthetic theorising. This is not altered by the fact that references to the straight line as the representation of 'the consciousness of a new culture' can be found in van Doesburg's writings as early as 1912. Apart from anything else, it would be unthinkable to attribute any such authority to van der Leck, who showed extreme prejudice in his attempt to exclude architects from any kind of collaboration in the movement, although one of its declared aims was 'to bring together the currents of contemporary thought pertinent to the arts'.

This desire for the various figurative arts to work together, which is implicit in the concept of 'plasticity' as elaborated by Mondrian, led from the outset to the collaboration of painters (van Doesburg, Vilmos Huszar, Mondrian), sculptors (Georges Vantongerloo), poets (Antoine Kok), and architects (J. J. P. Oud, Robert van't Hoff, Jan Wils, Gerrit Thomas Rietveld). As Jaffé rightly points out, however, 'It would be illogical and contradictory, when dealing with a collective movement like De Stijl, to ask who started it.'[2] The theoretical premise of De Stijl's syncretism is contained in the constructive principle of methodological unity.

De Stijl had, from the beginning, a distinctly secular and social bias and intended to create a style 'based on the pure equivalence of the spirit of the age and of the means of expression', which would be realised with full reference to society and would contribute to the 'reform of aesthetic sensibility and to the emergence of plastic consciousness'.[3]

This consciousness is not the consciousness of the single individual, but the collective consciousness, developed on a plane of civilisation which is in continuous evolution according to a progressive pattern of social dynamics.

This concept of the new was not the exclusive prerogative of the members

2 H. L. C. Jaffé, *De Stijl* 1917–31, Amsterdam, 1956. Contesting the legitimacy of an art-historical method based exclusively on the development of the arts within themselves, and emphasising the necessity of broadening the enquiry to include sociological considerations, Jaffé has demonstrated, with a very well-documented reconstruction in depth, the marked ideological character of the movement and its direct participation in the extra-artistic field of social factors, scientific and technological progress, and human relations which constitute that 'common consciousness of the age' expressed in Neoplastic art.

3 From the introduction to the first number of *De Stijl*. Quoted by Michel Seuphor, *Piet Mondrian*, Cologne, 1956; English edition, *Piet Mondrian, Life and Work*, Thames and Hudson, 1957, p. 141.

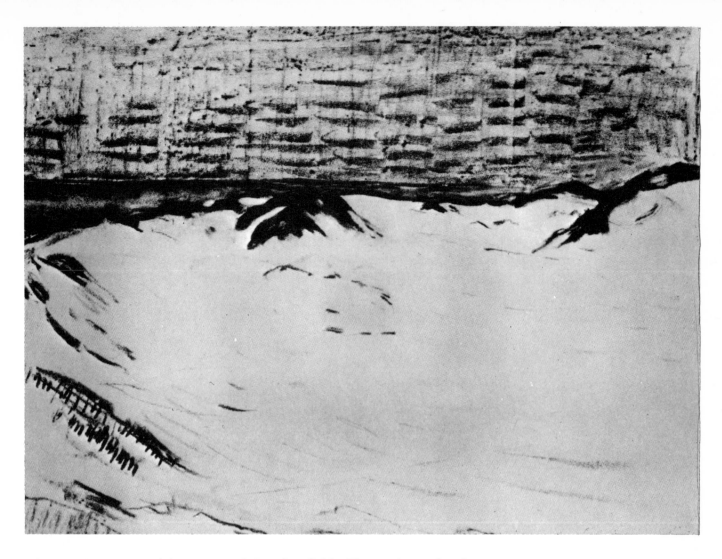

4 *Dunes*
c. 1909, charcoal
$18\frac{3}{4} \times 24\frac{3}{4}$ in (46×63 cm)
private collection,
Marseilles

of De Stijl; it emerged from research in other fields. Thus artists and writers were aware of living in an epoch of particular importance in the history of mankind: an age with great possibilities for social improvements through technological and scientific progress, to which the only obstacle was traditional prejudice and the legacy of Romanticism. The First World War, soon raging throughout Europe, was also a result of traditional prejudice and error, but although it certainly profited from technology and science, to consider these the work of the devil solely for this reason would be irrational and anti-historical. Holland itself was neutral, but the war produced a climate favourable to change, and played its part in the dialectic of progress. De Stijl saw it as having a directly instrumental importance. 'The war is destroying the old world and its contents: it is destroying in all nations the predominance of the individual', wrote Mondrian in the second volume of *De Stijl*.[4] In 1943, speaking of the Second World War, he wrote: 'Even in this chaotic moment, we can near equilibrium through the realisation of a true vision of reality. Modern life and culture helps us in this. Science and techniques are abolishing the oppression of time.'

The important thing, therefore, was not to nourish a guilt complex over the products of human activities, but to lead the use of science and technology back into the field of human progress. From this arises the need to acquire and develop a solid critical understanding, beginning with a recognition of the painful discrepancy that exists between the programme and the actual circumstances. A sense of civil responsibility which acts through art as much as through pure science and the perfection of technical knowledge called on to resolve the great historical conflicts, underlines the pre-eminence of spiritual tendencies, as opposed to strictly political ones, in social life.

4 Quoted by Jaffé, *op. cit.*, p. 168.

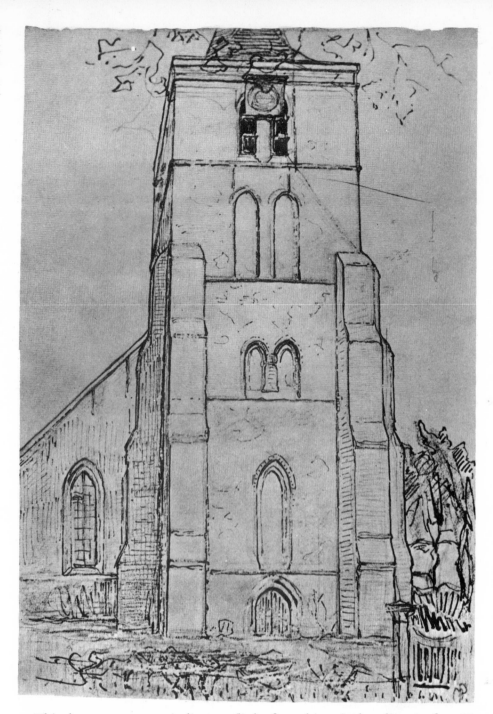

5 *Church Tower at Domburg*
c. 1909, drawing
16 × 11 in (41 × 28 cm)
Gemeentemuseum,
The Hague, Slijper loan

This does not seem to indicate a flight from historical reality; in fact, De Stijl acknowledged the importance of history, and placed itself dialectically in a historical position by developing both the theoretical values of Cubism and the formal values of Frank Lloyd Wright's architecture. And the radically critical attitude with which it proposed to condition existence, together with the rational clarity of its method, influence the society in which it is found much more profoundly than any contingent ideology.[5]

With premises such as these and with this attitude to life and society, it was inevitable that the theories developed by De Stijl should be in opposition to both the distant and the more recent past. These theories demanded the rigorous abolition of particular forms, the absolute purification of the plastic language from any accidental quality or individual emotion; the realisation, through the *Nieuwe Beelding,* of a universal spirit which would be apprehended as the fundamental norm by means of an exemplary art of exact

5 This type of commitment is similar to the 'non-politics' of Gropius, who showed how it was possible to remain outside a contingent ideology while still adhering to the cultural and historical factors of the time. In connection with this *see* G. C. Argan, *Walter Gropius e la Bauhaus,* Turin, 1957: 'The technicism of Gropius can, strictly speaking, be interpreted as non-political, in the sense that it seeks to resolve, or avoid altogether, all ideological conflict by lucid, social functionalism: a different motive from the attitude of Mann and those German intellectuals who made detachment from political competition a condition of their "commitment" on the cultural plane.' p. 19.

relations, equilibriums and equivalences. The polarities of De Stijl are, then, the ideal platonic world of the universal principle, which is concerned with the spiritual; and the world of life, which is concerned with society. Since it is art which has to unite these two; and since the new reality will be the work of aesthetic activity, De Stijl affirms the pre-eminence of its spiritual discoveries. It establishes and sums up its Utopia in the proposal that art must be the representative of our daily actions: 'Spirit overcomes nature, mechanical production supersedes animal power, philosophy supplants faith.'[6]

Neoplasticism in architecture

Architecture occupies a position of the first importance in the De Stijl system, and represents the secular consciousness of the movement. It is also important to emphasise that the utopian aspect of De Stijl is much less evident in this field. In 1925 van Doesburg wrote: 'The new architecture is economical, that is to say it utilises its elementary means in the most efficient and economic way possible, without any waste of means or materials. The new architecture is functional, which means that it is developed from a precise definition of practical needs established with the maximum of clarity in the plan.' Oud stated that: 'The substitution of handicraft by machine-work –a social and economic necessity–begins to assume larger proportions in the building trade. Though at first obstinately kept out of the way by the aesthetes, the application of the mechanical product is spreading more and more, in spite of all opposition.'[7] According to Van Eesteren: 'Chaos rules in all our modern cities and industrial areas. Instead of increasing the individual's joy of living, technology tends to stifle it. Some architects have understood this. They have begun to bear in mind the problem of how to overcome this chaos, and to do this they have started out not by reflecting on the form of a city, but by attempting first of all to discover the underlying reasons for the chaos . . . The modern town-planner, therefore, is concerned with moulding the city, that is, the ever increasing area of the countryside that is being absorbed by the city, since he sees it as a symptom and expression of modern life. It is the task of town-planning to study and prepare the re-organisation of our cities and the natural purpose, the distribution, and the factors involved in the occupation of the land.'

This practical attitude of the architects of the De Stijl movement began to be defined in 1923, after an initial period of speculation. This date marks the beginning of an experimental methodology and a new type of planning which took into account the practical realisation of the project. The new system can be seen in action in Rietveld's Schröder house at Utrecht (1924), the first product of De Stijl architecture and the authentic embodiment of the austere, technico-abstract concept of architecture which Mondrian had in mind.[8]

The concept of functionalism and the modern techniques of production which exclude 'personal vagary' and entrust the execution of a project to others establish the anti-individualistic spirit of the group on the model of collective institutions, and on the principle of the division of labour which sociological research as early as 1893 had indicated as the foundation of Western social organisation.[9] These ideas led later to the development of the functional constructivist architecture of the German *Neue Sachlichkeit* (New Objectivity), and their influence was still active in the rationalism of Le Corbusier.

These standards for architecture, which were applied to all the arts (van

6 J. J. P. Oud, *Hollandische Architektur*, quoted by Jaffé, *op. cit.*
7 J. J. P. Oud, *op.* and *loc. cit.*
8 Argan maintains that in spite of everything De Stijl showed an 'insufficient awareness of social problems', indicated by the 'almost Neoclassical character' of its formalism; so that, according to Argan, 'Rietveld's house has the same canonical value as a model for modern habitation as Bramante's Tempietto of San Pietro in Montorio supplied for the religious architecture of the 16th century.' *Studi e Note* cit., pp. 169–70. On the architecture of De Stijl in particular *see* B. Zevi, *Poetica dell'Architettura Neoplastica*, Milan, 1953.
9 Emile Durkheim, *De la division du travail social*, 1893; English translation: *Emile Durkheim on the Division of Labour in Society*, New York, 1933.

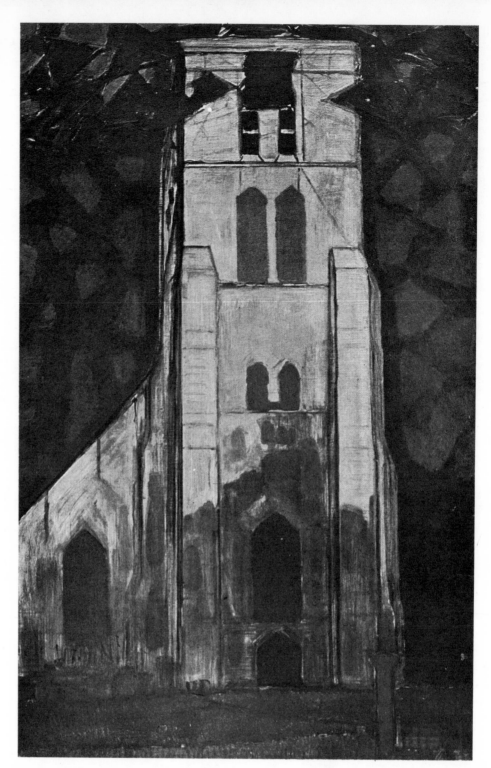

6 *Church Tower at Domburg*
c. 1909, oil on canvas
44¾ × 29½ in (114 × 75 cm)
Gemeentemuseum,
The Hague, Slijper loan

Doesburg held that 'since the new spirit requires the greatest precision . . . only machinery, with its absolute precision and its modern devices, is capable of satisfying the highest needs of the creative spirit') explain the objective, almost mechanical, morphology of the De Stijl images; they restrict its utopian quality, although in painting the functional stimulus took on an exclusively theoretical and programmatic form.

It has been said that in this sense Mondrian's painting is like a ground-plan, a town-planning project. His strict reduction of forms to an anti-individualistic, objective, unemotive, scientific pattern, is a technique in which the spirit of all the new ideas and attitudes of the age, summed up emblematically in the metropolis, finds its visual form. In 1919 he had written: 'The truly modern artist considers the metropolis as the embodiment of abstract life; it is closer to him than nature, it will give him an emotion of beauty. For in the metropolis nature has already been straightened out and regulated by the human spirit. Social life, cultural life, find their most complete manifestation in the metropolis.'

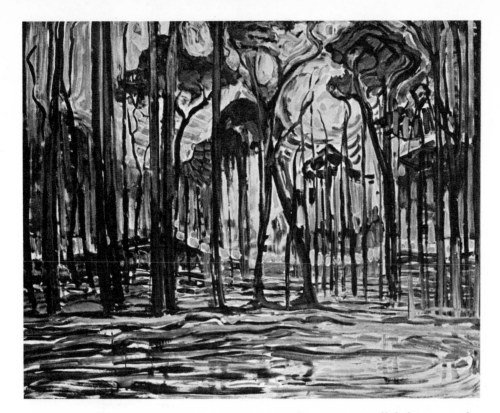

7 *Woods*
c. 1910, oil on canvas
$50\frac{1}{4} \times 62$ in (128×158 cm)
Gemeentemuseum,
The Hague, Slijper loan

Seen in their ecological aspect, these considerations parallel the researches of sociologists into the structure of social relationships within the environment. The fact that the principles of spatial division and distribution established by De Stijl cannot be empirically verified, and thus are utopian, does not in any way deprive them of a special methodological value. They are utopian in their constant repudiation of the accidental, in their continuous efforts to alter the *status quo,* in the refusal of the 'dominant concept' which is very similar in meaning to the 'total concept of ideology' investigated by Mannheim.[10]

By 1925 Mondrian had stopped contributing to *De Stijl* because he disagreed with the principles of Elementarism, a movement started by van Doesburg. This action is typical of Mondrian's inclination to axiomatic orthodoxy, and suggests the sectarian spirit of the Calvinist and Dutch Protestant tradition. Van Doesburg's shifting of the lines by 45 degrees in his *Counter-Composition* represented for Mondrian a deviation from the original conceptions of De Stijl, and was sufficient reason for him to leave the group.

All that has been said so far indicated the difference between De Stijl and Neoplasticism and other rationalist movements in European art in the second decade of this century.

In Russian Suprematism, apart from its basic nihilism, there is still a naturalistic visual reduction of movement (Malevich), so that the requirements of the reductive image still predominate in the traditional way. In pure Constructivism, the aesthetic problem is subordinated to the technico-functional problem of structure. The empirical functionalism of the Bauhaus was to be directly involved with industry, and so did not have the pure detachment of Mondrian's methodology.

The relationship between De Stijl and the Bauhaus was none the less close, and in spite of the disagreements between Walter Gropius and van Doesburg, which were often bitter, the theories of De Stijl played an important part in the change of direction which took place in the Bauhaus between the Weimar period and the Dessau period in 1925.

The first direct contact between the two movements took place in 1920

The Bauhaus and Concrete Art

10 Karl Mannheim, *Ideologie und Utopie,* Bonn, 1929; English edition, *Ideology and Utopia,* London, 1936.

8 *Dune*
c. 1910, oil on cardboard
11 × 15¼ in (28 × 39 cm)
Slijper collection,
Blaricum

during a visit by van Doesburg to Berlin, and the following year he went to Weimar at the invitation of Gropius. After this the contacts became more numerous: *De Stijl* was printed in Germany, and van Doesburg gave a series of lectures in Berlin, Hanover and Dresden, and organised an unofficial branch of De Stijl at Weimar. In 1924 the exhibition of the architectural work of De Stijl, held in Paris the previous year, was brought to the Bauhaus. In 1925 Mondrian's writings on Neoplasticism were translated into German, and Oud's *Bauhausbuch* was published the following year.

The most obvious effect of the influence of Neoplasticism in Germany can be seen in the architecture of the *Neue Sachlichkeit,* that is of the new functional, constructivist objectivity. Bauhaus theory, however, followed a different path from that of Neoplasticism. Mondrian defined all space through the plane; Gropius thought of space in terms of human activity translated into furniture or the living unit. Mondrian sought for structure; Gropius followed life. Bauhaus designs aimed at a functional empirical result, whereas Neoplasticism was concerned with the formulation of absolute ideas; Bauhaus was more interested in didactics than in style. Gropius, living in the social and economic context of Weimar, was concerned with establishing a 'new continuity between art and technology'; his theories were practically directed towards a bourgeois conditioning of industrialism in spite of his emphasis on quality above quantity. De Stijl wanted to unite art with the universal spirit and with life.

Both movements sought to alter the existence of man through a constructive activity, but whereas Gropius went no further than function, that is, the immediate value of the form, Mondrian formulated a *Weltanschauung* (vision of the world). Later, through the Paris exhibition of 1923, the principles of De Stijl influenced Le Corbusier in his development from a Cubist to a rationalist style of architecture. They were also behind the 'Cercle et Carré' group of Seuphor and Torres Garcia (1930), the 'Abstrac-

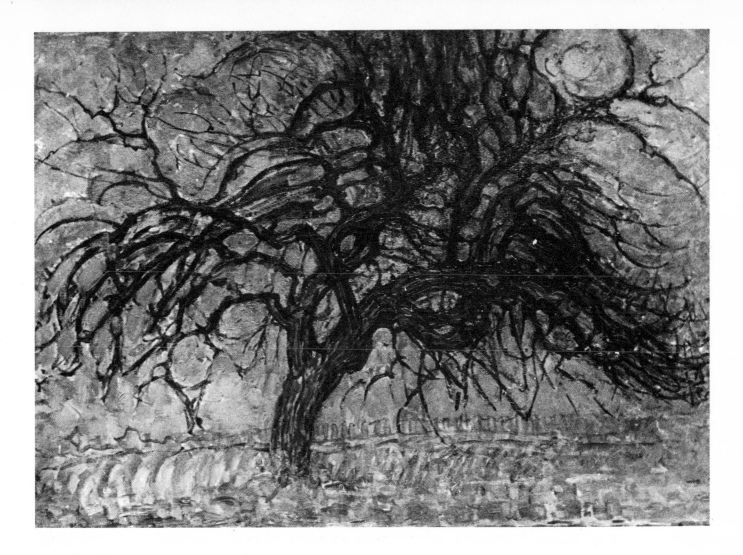

tion-Création' group of Vantongerloo and Herbin, and, in practice, all the definitions of Concrete art in Europe between the two wars.

Mondrian's poetics

If De Stijl was concerned with the immanent, that is, the social context, the concept of art defined by Mondrian in his writings belongs to a higher order. Aesthetic activity is part of existence, just as it is the most suitable means of penetrating the world of existence and overcoming the barriers which divide the temporal from the eternal. In a notebook of 1914 he wrote: 'Between the physical sphere and the eternal sphere there is a frontier where our senses stop functioning. Nevertheless the other penetrates the physical sphere and acts on it. Thus the spiritual penetrates the real . . . To approach the spiritual in art, one must make as little use as possible of reality, because reality is opposed to the spiritual. Thus the use of elementary forms is logically accounted for . . . Art should be above reality, otherwise it would have no value for man.'[11]

This call for the spiritual in art invites a comparison with Kandinsky, the first contemporary artist to apply the concept of abstraction; his famous book *Über das Geistige in der Kunst (Concerning the Spiritual in Art)* was written in 1910 and published in 1912. He derived his concept both from psycho-physiological insights and from a wide range of aesthetic culture which included psycho-formalist theories on the principle of *Einfühlung* (R. Vischer, Volkelt, Groos, Lipps, Worringer etc.) understood as the relinquishing and projection of our subjectivity into objects; and the enquiries into the nature of visible form of Fiedler, Hildebrand and Riegl, whose figurative formalism was based on the perception of visual values divorced from any cultural or emotional content *(Sichbarkeit)*.

Mondrian's theosophical metaphysic, which will be discussed more thoroughly later, is undoubtedly similar to the emotive spiritualism, the

11 Quoted by M. Seuphor, *op. cit.,* p. 117.

9 *The Red Tree*
1909–10, oil on canvas
27½ × 39 in (70 × 99 cm)
Gemeentemuseum,
The Hague

inner spiritual agitation, expressed by Kandinsky. Apart from this basic analogy, however, Kandinsky's abstract spiritualism was the expression of an inner necessity, so that the image, besides being the direct representation of the inner life in its essence, was also an organic liberation of the sub-conscious, which finds expression through art.[12] For Mondrian, on the other hand, the all-important problem is an absolute, objective language, in which the forms, although they derive their ontology from a transcendental mystical presence, are not allowed to be obscured by any accidentals, whether external or internal. He is concerned with an intensive search for the interior structure of the world, the perennial, unchanging essentials, theoretically expressed through the image.

This activity is practised with a constant rational and scientific control of the plastic language, exemplified by the elimination of the curve, which he saw as an ambiguous expression; the exclusive use of the line and right angle; the theory of abstract 'relations'; the system of harmonic spatial divisions; and the ontological analysis of the plane. The completely objective forms obtained by this technique correspond to the actual laws of con-struction (here again there is a connection with architecture) and harmonious expression, and so with the universal logos.

Mondrian's technique has, therefore, a structural aspect in the sense that the essence of the real cannot be captured and expressed except by means of the image which represents it, and otherwise remains inexpressible.

This reference to the transcendency reached through art does not exclude, and indeed even implies, that no knowledge is in fact possible outside the concrete aesthetic act. Mondrian himself, when he wrote, with reference to the theory of the psychology of form, that art is 'the plastic expression of our aesthetic emotion' was careful to make it clear that 'in the new representa-tion reason takes first place'. Axioms such as this, considered in connection with the rigorous desire to overcome the limitations of the subjective, show that the critical activity which directs the consciousness at the moment of action is analogous to an entity such as Kant's transcendental 'I', in the sense that the order of things subsists to the extent that our consciousness con-structs it in the act of understanding.

We are thus faced with a sort of *a priori* form of the knowledge which synthesises in itself the moment of understanding, the moral moment (that is, the duty for every end to be desired in its rational form, which is also the law of freedom) and the aesthetic moment. This is a vision which goes beyond the limits of Kant's problematical aesthetic and is more immediately and closely paralleled in Fiedler's elaboration of Kantian thought. It is curious that even the most thorough expositions of Mondrian's ideas do not examine Fiedler's contribution to this question in any depth. Fiedler's Aphorism No. 145 could be said to sum up Mondrian's position. 'What else, at bottom, is man's spiritual activity if not a continual preserving of himself from the eternal flux of the sensible world in the sphere of fixed forms? And this salvation is accomplished in artistic figuration no less than in the construction of concepts.' Fiedler's idea of art as a form of knowledge that 'finds proper mediation and revelation in art' (Aphorism No. 179), is, apart from anything else, the central concept of Pure Visualism, which is generally acknowledged as one of the sources of De Stijl. This, while it documents the historial continuity of Fiedler's thought, would not justify the interpretation of De Stijl's plastics as Parnassian, part of the art for art's sake current, even in the light of less orthodox declarations like some of van Doesburg's ('Beauty is valid in all ages, because aesthetics, with its universal values, overcomes time'; 'Art is an end in itself.'). The references to art as an end in itself, frequent in van Doesburg's writings but also present in Mondrian's, should be interpreted as freedom from the accidental and from any ideology that is not pure, i.e. utopian.

The concept of art as a formative principle, and thus of form as formation,

12 G. Morpurgo Tagliabue in *Il Concetto dello stile,* Milan, 1951, sees the anticipation of 'certain aspects of Sartre's existential psychoanalysis' in Kandinsky's abstractism, p. 237, note.

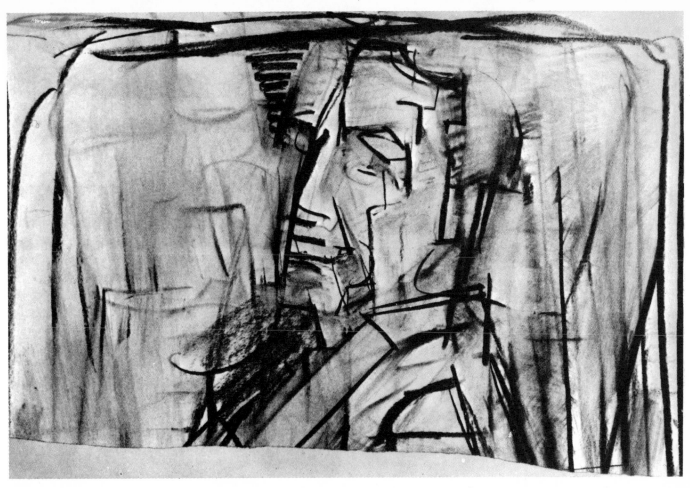

that is, as a positive way of understanding and constructing by means of form beyond any obscuring of content by subjectivity, documents, in Banfi's words: 'a radical policy, a commitment to creating in art a concrete reality, experience itself, intuitively purified and expressed in the tension of vigorous effort'. 'In breaking through the opaque solidity and uncertainty of experience', Banfi continues, 'The pure, fixed, clear qualities of art constitute an unequivocal reality, brought about by human activity, not a reality of vision or dream, but a concrete and expansive reality which, through its relativity, brings order and harmony to the tragic and chaotic relationship in everyday life between man and the world.'[13] We are back to the theme of eliminating the disequilibrium between the individual and the universal, the tragic aspect of life, which was the fundamental aim of Mondrian in his pursuit of the New Order.

Both the Symbolists and Kandinsky believed that music was the expressive form which best achieved this purpose. But although music is not hampered by naturalistic references, it is nevertheless involved in the everyday tragedy and in lyrical soliloquy. For Mondrian and his colleagues the most satisfactory form was architecture. They saw architecture as the expression of man's capacity for designing; it could be achieved without recourse to subjective feeling, utilising the pure plastic logic which realises the universal rationale in the world of contingency. In this aesthetic system, painting will be the pure project, the *a priori* form which precedes experience: that is, the perfect plan, which will be carried out in architecture, and which, as architecture, will have to measure itself (and perhaps be altered or destroyed) against the world of experience. Painting and architecture thus become respectively Utopia and reason, to the extent that without Utopia (dogma) there can be no reason (criticism), because if form is the very condition of experience, it is from and in experience that form is created. If, therefore, architecture is the accomplishment of the universal previously stated in painting in the particular, it must not be forgotten that Mondrian reached this universal language by analysis and deduction, by breaking down

10 *Self-portrait*
c. 1911, chalk drawing
$19\frac{1}{4} \times 28\frac{3}{4}$ in (49 × 73 cm)
Slijper collection,
Blaricum

13 A. Banfi, *Preface* to the *Aforismi sull'arte* of K. Fiedler, Milan, 1945.

and reconstructing a whole tradition of naturalistic and historical forms. Schematically, his aesthetic reasoning goes like this: from the naturalistic particular of phenomena, to the universal of concept (noumenon), and through this, back to the particular, no longer naturalistic but social, by means of architecture.

In this way, painting becomes a phenomenon only by being converted into architecture; on canvas, it is still 'noumenon'.[14]

An interpretation of Mondrian from this angle, justified by a wealth of theory and by concepts such as the 'architectonic-chromoplasticism' already mentioned or 'plastics as picture', enables one to reconcile certain apparent contradictions, both theoretical and programmatical, in the aesthetics of De Stijl. One such contradiction is the antagonism, in practice, between Mondrian's spiritualistic, mystical and modernist vision and the technicalist vision of the architects.[15] On this basis, moreover, it is somewhat difficult to relate Mondrian's painting to the phenomenological descriptiveness typical of Gestalt psychology, this relationship being one of the theses advanced by Argan. In indicating, however, the high proportion of Gestalt in his configuration of the ultra-informal phenomenon, Argan had to demonstrate, on the contrary, that Mondrian's geometry was definitely noumenal.

Mondrian's aesthetic and intellectual concepts are derived from a heterogeneous variety of sources, ranging from the metaphysical rationalism of Descartes, Leibnitz and Spinoza, to Kantian criticism and a mysticism drawn from a number of sources. To complete this summary outline (and it can be no more than an outline, although it will be necessary to go into some aspects more deeply as we proceed) it is necessary to show how the theme of the capacity of the spirit, in contrast to nature, to be reduced to universal abstractions, which is the central theme of Mondrian's work and the key to its critical understanding, and which was repeated axiomatically by him on many occasions, is typical of a German idealism drawn chiefly from the Hegelian concept of speculative universalism. Van Doesburg, as Jaffé notes in describing the spiritual foundations of his theories, also indicates that the laws elaborated by Hegel are given visual form in Neoplasticism. Mondrian's mysticism, on the other hand, stems from complex origins which include elements both of Neoplatonism and of *fin de siècle* culture (Symbolism, Synthetism, Far Eastern philosophy, Theosophy, philosophy of the unconscious etc.). The messianic policy of unveiling existence was also, as Menna has indicated, derived from the transcendental basis of German idealism filtered through Schopenhauer, whose works were attentively studied by Mondrian.[16]

For Schopenhauer, however, the pendulum of life swung between suffering and tedium, and the only alternative to this condition of existence was aesthetic; whereas for Mondrian, once the tragical aspect had been understood, the way to overcome the contradictions of life was through reason, which orders the world as the product of man, and transcends both the particular and the individual in the harmonious universal spirit and in anonymous collective experience. In short, art for Mondrian became the instrument for collective salvation on earth, whereas spiritual exaltation for Schopenhauer was through supernatural individual grace. Mondrian's mysticism is to be understood in a secular sense; he approached the supernatural not through revelation but through reason and science, as a Utopia, in fact, of social metempsychosis. In this way he recovered the old dream of a reconquered Eden which had nourished the German Romantics, trans-

14 Argan, in *Studi e note* cit., p. 159, although recognising the conceptual nature of De Stijl's form, considers it phenomenal, and describes its aesthetic as 'on the borderline between idealism and phenomenology', thus revealing the two contradictory factors (the one critical and the other dogmatic) on which the movement's programme is based. The function of architecture, in the sense in which it is interpreted here, could resolve this contradiction.
15 Cfr. F. Menna, *Mondrian,* Rome, 1962, p. 21 ff.
16 *Op. cit.* For a clear treatment of the philosophical components of Mondrian's thought see Menna's work.

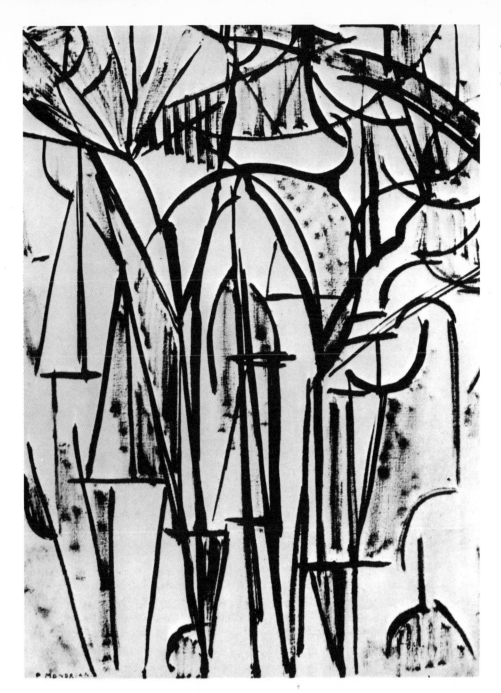

11 *Composition with Trees*
c. 1912, oil on canvas
$31\frac{3}{4} \times 24\frac{1}{2}$ in (81×62 cm)
Gemeentemuseum,
The Hague, Slijper loan.

ferring it to the sphere of social life where man would be able to redeem himself through the demiurgic and integrating work of the artist.

Mondrian's formal analytics

We have said that all the stages of Mondrian's development, which started from the naturalistic and step by step evolved a plastic language for translating abstract thought and the technological, geometrical world of his epoch into visual form, can be interpreted on the plane of an ethical aesthetic teaching. Now, if Mondrian's scrupulous adherence to actuality is the indication of a consciousness of the historical situation in which the origins of our ills are immanent, from this consciousness, which changes with time, is born an aesthetic reduction which also varies in the same way. This means that reality and art are transferred to the extent to which rational experience intervenes in their progress. At this point the question arises of the continuity of Mondrian's researches. That is: was Neoplasticism a higher vision, abruptly manifested without links or similarities with the preceding development and therefore in itself imperfectible? Or was it the foreseeable result of a system of formal analysis which, understanding reason as a process, saw itself also as susceptible of evolutionary change? Some critics seek to prove, on the evidence of Mondrian's own writings, that there is no connection between the work before the Cubist experiments and his develop-

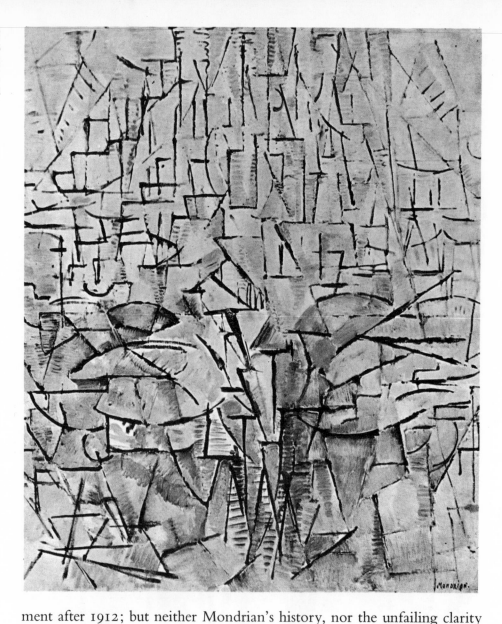

12 *Composition No. 3*
1912–13, oil on canvas
37½ × 31½ in (95 × 80 cm)
Gemeentemuseum,
The Hague, Slijper loan

Figs. 1–9

ment after 1912; but neither Mondrian's history, nor the unfailing clarity of his logic support this theory. If we accept–just to glance at the problem in passing–that Cubism was for Mondrian an authentic revelation of a formal solution, it will be necessary to specify that this revelation played a subsidiary, and primarily cultural, role in the development of his artistic language, which as early as 1907 showed remarkable analytical tendencies; until by 1910 he was already using a definitely abstracted arrangement. This was particularly evident in some of his drawings, such as the series of *Flowers*. Cubism acted as a morphological catalyst, and probably as the confirmation and solution of aesthetic problems that had already had their slow, interior and necessary period of incubation during the naturalistic phase of Mondrian's painting. A failure to recognise the importance of the deductive and evolutionary criteria applicable at every stage in Mondrian's analytical development would leave unexplained the transition from Cubism to the *Nieuwe Beelding*. Neither would it take into account the relevance of the part played by theosophical synchretism in the development of his interest in Japanese architecture[17], which must lead us to the hypothesis of a gradual formative evolutionary process. Thus it is clear that Cubism was only a stage, albeit an important one, in the search for the final truth expressed by Neoplasticism. The connection between the two styles becomes clear if we suppose researches into the rhythmic image to be one of the roots of Neoplasticism; such researches were not restricted to Mondrian, but were also made during these years by the future promoters of De Stijl, van der Leck and van Doesburg, between 1916 and 1917.

17 See M. Seuphor, *op. cit.*, and D. Gioselfi, *La Falsa preistoria di Piet Mondrian e le origini del Neoplasticismo*, Trieste, 1957.

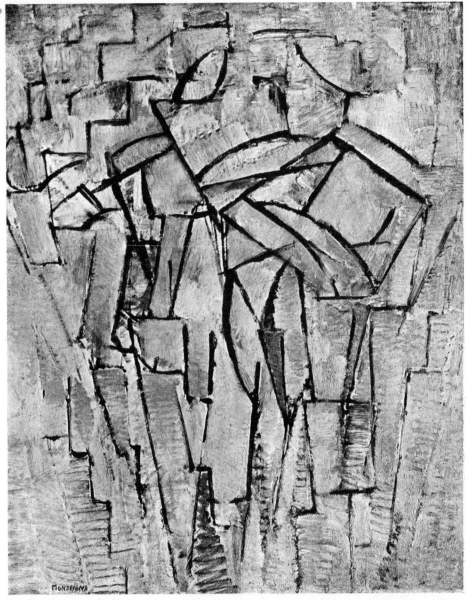

14 Composition with Grey and Blue
c. 1912, oil on canvas
$38\frac{1}{2} \times 25\frac{1}{2}$ in (98×65 cm)
Slijper collection,
Blaricum

Haags collection and the *Evolution* triptych (*c.* 1911). In these works a perceptive sensibility derived from Van Gogh is expressed in stylistic terms which in addition to elements of Art Nouveau, Pre-Raphaelitism and Expressionism, also draw on cultural sources such as Japanese engraving (*The Farm at Duivendrecht*).

The paintings also display a broad, structuring divisionism, a technique practised at this period by Jan Sluyters, a former companion of Mondrian's at the Academy, with whom he exhibited in 1909 at the City Museum in Amsterdam, and other minor artists such as Leo Gestel. They seemed to disregard the scientific dogma of Seurat and Signac, in favour, on the one hand, of the Expressionist teaching of Van Gogh and Breitner, and on the other, of the visionary, theosophical symbolism of Toorop. Towards the end of the 1910s this type of painting developed further into a Neo-Impressionist Fauvism, with broad mosaic patches of colour reminiscent of Matisse.

The range of colours used in the paintings of this period are in the Fauve key, much brighter than those of the earlier landscapes. Primary colours are preferred to natural colours, and are laid on in patches, always emphasising a tense, dramatic quality of mysticism and morality which reminds us of the tormented expressions of Van Gogh.

The prelude to abstraction, therefore, is principally conducted along the Van Gogh-Munch tangent. The flexible arrangement of body colours and large divisionist brush strokes (Van Gogh), together with the undulating effects of broad, fluid compositional synthesis (Munch), which gives rise to a symbolistically stylised spatial reduction, and a broad synthesis of immobile frontal images. But whereas for Van Gogh art, as a completely

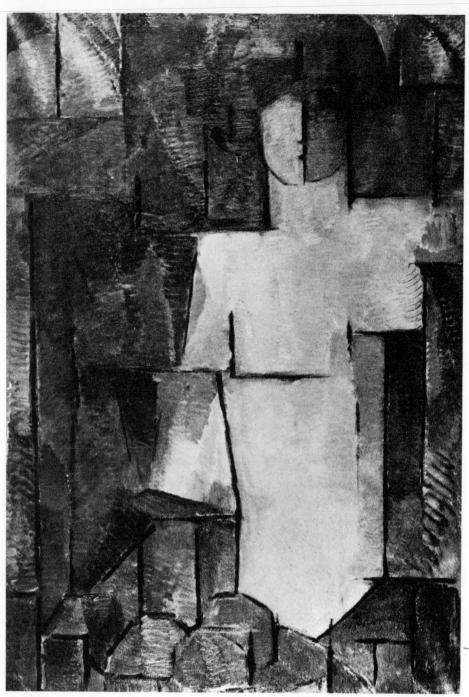

personal experience, was a way of 'living through death' (Argan), Mondrian, although he was animated by a similar moral fervour, soon resolved his poetic in a vital direction intended to widen the consciousness of man, which in its preliminaries was involved in the field of spatial analysis and the deciphering of the world.

The repetition of a single theme to gain a deeper understanding of it from different aspects is a prelude to the analysis of form and space of Mondrian's Cubist experiments.

The Trees Cycle The series of rigorous formal abstractions of *Trees* (1909–11), which reveals the workings of a logical reductive vision, is one of the most coherent and rational expositions in all contemporary art, and marks a transitional stage in Mondrian's development, as well as providing an introduction to his later style. The form, which at first penetrates the space with Expressionist and Secessionist cadences (*The Red Tree* 1910: reminiscences of Van Gogh; the movement of the Art Nouveau style; the chromatic definitions of Fauvism) becomes itself pure spatiality, with references to geometrical relations, and an analysis of form already perfectly in line with Cubist experiments. His object was to discover the underlying structure; the series is an exhaustive search for the hidden web of relationships which is concealed

Fig. 9

beneath the misleading appearance of natural phenomena, which, by revealing its permanent laws, forms a bridge between the universal and the particular; the static and the dynamic; the individual and the world.

Seuphor writes that at this point, having passed beyond his Expressionist phase, Mondrian became the heir of the other great line of Dutch painting: the stylistic tradition of Vermeer, which extended to Toorop and van der Leck. Mondrian himself acknowledged the influence of van der Leck, which occurred at the moment of his definite transition from Cubism to Neoplasticism.

Mondrian's contact with Cubism coincided with his move to Paris in 1912, but it had been anticipated as early as 1910 when he saw works by Braque, Léger, Picasso, Gleizes etc. in Holland, through the agency of the Amsterdam critic, Conrad Kickert. The impact of the style led to his final break with natural forms and to the definition of his theories of art.

A full documentation of Mondrian's researches into Cubism is provided by the two versions of *Still-life with Gingerpot* of 1912, or later examples of the *Trees* series from about 1913, which show a complete development of Analytical Cubism.

The Paris of 1912 was a ferment of aesthetic ideas and speculations; Post-Impressionism, Fauvism, Expressionism, Futurism and Cubism were all at their height in that year. In the Cubism of Picasso and Braque Mondrian found a promise of mental order. There were also more direct affinities

The Cubist period
Pl. 14, Fig. 16
Pl. 17, Figs. 11–14

16 *Still-life with Gingerpot I*
1912, oil on canvas
$25\frac{1}{2} \times 29\frac{1}{2}$ in (65×75 cm)
Gemeentemuseum,
The Hague, Slijper loan

between these artists: in the deductive analysis of Cubism, in which art was conceived as a cognitive activity, Mondrian saw the most suitable method of achieving, by means of abstraction, a total and absolute vision of reality. This vision was not to be captured by the Cubists, however, even in the most advanced stage of the Synthetic Cubism of Picasso and Braque, because they did not develop their principles to their logical conclusions. They stopped short (or even, in the Surrealist involution, actually retrogressed) and it was left to Mondrian to continue the logical development of their researches. 'Gradually I became aware that Cubism did not accept the logical consequences of its own discoveries; it was not developing abstraction towards its ultimate goal: the expression of pure reality.'[21]

For Mondrian the painted surface was profoundly differentiated from nature by its absolute objectiveness; in this revindication of the creative autonomy of art understood as the instrument of knowledge he was in agreement with the Cubists. It was also the key for penetrating the underlying reason of the world, discernible beneath the exterior appearance of phenomena. The most crucial difference between Mondrian's approach to reality and that of the Cubists can be traced partly to the differences in the origins of their two cultures. Behind Mondrian lay an expressionism based on a deep and persistent moral involvement. The Cubists, on the other hand, the heirs of Cézanne, carried on his work of breaking down objects into their 'primitive volumes' without any overt ethical preoccupations. Mondrian used phenomena to search out their rational value, the ideal law of forms which, through man, modify reality and are realised in absolute freedom from the obligation to communicate. The Cubists remained on the level of the phenomenon, although they tried to find the rules according to which it manifests itself and links itself in time and space with other phenomena, and which regulate its sensible (that is figurative) modification within an extensive and multi-dimensional space.

Mondrian was not interested in the specific aims of the Cubist style, such as multiple perspective, the breaking down and reconstitution of objects, spatial condensation, and the multiple representation of the same object simultaneously. His method of investigating form centred on the organisation of the surface as the analysis, concentration or synthesis of images. His fundamental concern was to liberate form from any particular definition; to purify vision from the contingent, and so to isolate the object from the instability of phenomena by assigning it to a higher order. Mondrian passed from the figurative to the totally abstract without going through the intermediate non-figurative phase, and for him, the hidden links between objects which the Cubists discovered in their analytical phase (the concept of duration in the simultaneity of vision which also occupied the Futurists and was derived from Bergson), were only an initial and relative stage in the more complex and more organic search for a universal order in the world.

His painting reached into the innermost recesses of reason, penetrating its vital and evolutionary processes, and achieved a logic which discarded completely the illusory qualities of cultural and linguistic convention. This is why in Neoplastic art the Cubists' third and fourth dimensions—depth and time—were abandoned as being extrinsic, mystical, and therefore not rational. Neoplasticism used instead a two-dimensional surface geometry: a system in which there is no perspective and time is frozen into a permanent present, demonstrating the total repudiation of the sensible world and the declaration of an incorruptible and therefore static absolute.[22]

This geometry of Mondrian's is the outcome of a metaphysical philosophy which is to be examined more closely in later pages. The desire for a distilled essence of the natural world, is, however, directed towards a practical dimension anchored to the world of human events (architecture and technics) by an empirical spirit. In addition to this, there is an echo of the Bergsonian theory of evolution, one of the most important cultural foundations of

21 Quoted by Jaffé, *op. cit.,* p. 43.

Cubism, in the law of evolution which characterises all Mondrian's life and work and is reflected in the gradual evolution of the formative processes of his art.

Mondrian's plastic language is a result of his conviction that truth is not to be sought in appearances, but is hidden beneath the illusory qualities of the sensible world. This belief has parallels in Eastern thought, from which it was ultimately derived, but Mondrian was more directly indebted to the metaphysical writings of Dr. M. A. J. Schoenmaekers, a Dutch Theosophist, whom he met at Laren in 1916. This was one of the fundamental convictions of Dr. Schoenmaekers, whose ideas on the Positive Mysticism, a combination of Neoplatonism and the philosophies of the Far East, exerted a profound influence on Mondrian's thought. Mondrian also belonged to the Dutch Theosophical Society; for him Theosophy replaced his original Calvinism, the faith in which he grew up. The penetration of the absolute through the relativity of natural facts by discovering their underlying structure – this was the proposition discussed by Schoenmaekers in his books *The Faith of the New Man, Plastic Mathematics* (1916), and above all *Het Nieuwe Wereldbeeld* (*The New Image of the World*). The latter was, according

Schoenmaekers: the Positive Mysticism

17 *The Sea*
c. 1914, pencil
$4 \times 6\frac{1}{2}$ in (10 × 17 cm)
Harry Holtzman collection,
New York

22 In opposition to a possible metaphysical interpretation, Argan, in 1953, put forward a phenomenological explanation of Mondrian's spatiality, as the perception of chromatic facts placed in dialectic relation in the plane. According to such an interpretation Mondrian does not start from a geometrical concept but from a sensation, which is that of colour, and so from a direct experience of reality which finds the dimension of all possible objects in the two-dimensional space of the plane. Two-dimensional space is the negation of conventional perspective, that is of notions: 'only perception gives us the sense of living fully in the present, whereas the notion is always of the past' (*Studi e note* cit. p. 176), so that the value of colours and forms in a painting by Mondrian is a 'here and now' value, that is, completely phenomenal, although the way in which the colours and forms determine, in an absolute sense, the value of the consciousness is constant.
In a later study (*Mondrian: quantità e qualitá,* 1956, in *Salvezza e caduta nell' arte moderna,* Milan, 1964) this thesis is partially modified: painting is that which in modern architecture is the plan as opposed to the perspectives: 'the schema or generating principle of visual experience'. Forms are recognised as having an ideal nature involved in phenomenal reality through the search for, and revelation of the 'profound myths of the collective consciousness'; they represent 'the common basis of intellectual experience'.

to Seuphor, one of the very few books Mondrian possessed, together with the works of Rudolf Steiner and Krishnamurti.

Jaffé has emphasised the close connection between the doctrine of Schoenmaekers' and Mondrian's ideas. Positive Mysticism, which is itself also a Neoplatonic system of philosophy, claims the ability to penetrate nature through manufactured appearances, and by this means discover truth. In Schoenmaekers' own words: 'We now learn to translate reality in our imagination into constructions that can be controlled by reason, so as to be able to recover them later in natural realities, thus penetrating nature by means of plastic vision. A mystical insight, and certainly a positive mystical insight, is not concerned with any single fact as such. A positive mystical insight has even to describe a single fact as such as an illusion. Truth is: to reduce the relativity of natural facts to the absolute, in order to recover the absolute in natural facts. Is the expression of positive mysticism foreign to art? Not in the least. In art it creates what we call, in the strictest sense, "style". Style in art is: the general in spite of the particular. By style, art is integrated in general, cultural life. Nature, as lively and capricious it

18 *Church Façade*
1914, charcoal
38 × 24¼ in (97 × 62 cm)
Harry Holtzman collection,
New York

32

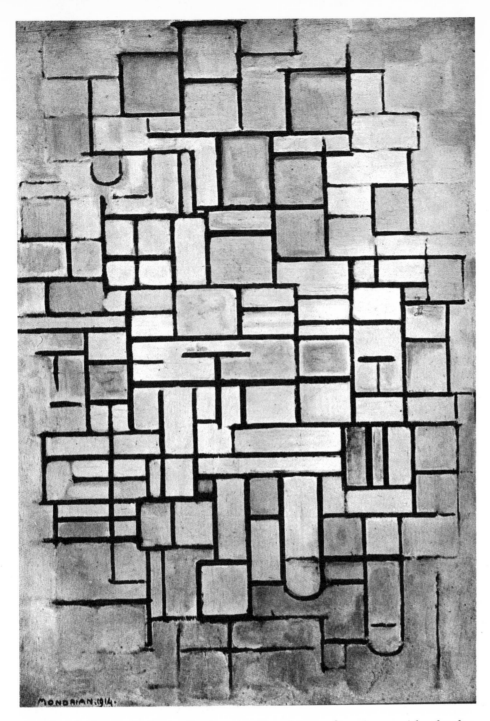

19 *Composition No. 6*
1914, oil on canvas
$34\frac{1}{2} \times 24$ in (88×61 cm)
Slijper collection,
Blaricum

may be in its variations, fundamentally always functions with absolute regularity, that is to say in plastic regularity.'[23]

In short, Schoenmaekers' fundamental belief in the relation between mathematical expression and natural reality, with its logical solution of the contradictions of reality, corresponded perfectly with Mondrian's own convictions.

The Nieuwe Beelding

With such principles the poetic of Neoplasticism necessarily came into conflict with accepted tradition. 'In nature', wrote Mondrian in 1926, 'relations are veiled by matter appearing as form, colour, or its natural properties. This "morphoplasticism" was unconsciously followed in the past by all the arts. Thus, in the past, art was "after nature". For centuries, painting plastically expressed relations through natural form and colour, until it came, in our day, to the plasticism of relations alone. For centuries, painters composed by means of natural form and colour; at present, the composition itself is the plastic expression, the image.'[24]

Mondrian therefore replaced the laws of symmetry and three-dimensional

23 M. H. J. Schoenmaekers, *The New Vision of the World,* quoted by Jaffé, *op. cit.*
24 Quoted by M. Seuphor, *op. cit.,* p. 166.

33

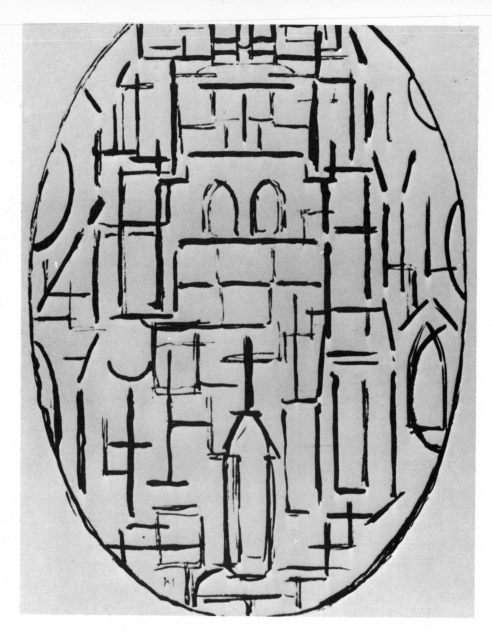

spatiality with an asymmetrical universe and a two-dimensional space as the elementary structure of the environment of contemporary man. This space was distributed, divided and strictly planned to an order which was no longer naturalistic, resolving in this way all conflict between art and life in a higher equilibrium. 'Balance through the equivalence of nature and mind, of that which is individual and that which is universal, of the feminine and the masculine – this general principle of Neoplasticism can be achieved not only in plastic art, but also in man and in society. In society, the equivalence of what relates to matter and of what relates to mind can create a harmony beyond anything hitherto known. By the interiorisation of what is known as matter, and by the externalisation of what is known as mind – until now, the two have been kept pretty far apart – mind–matter becomes a unity.'

The putting into practice of these principles was a gradual process. The *Quay and Ocean* series seeks to interpret the eternal rhythm of the sea. The following statement by Mondrian is an example of the analysis of the infinite directions of space in the plane: 'Observing the sea, the sky and the stars, I sought to indicate their plastic function with a multiplicity of crossing verticals and horizontals. Impressed with the vastness of nature I was trying to express its expansion, rest and unity.' In these paintings the particular, for instance the waves of the sea at Scheveningen, becomes more and more rarefied through cosmic feeling permeated with light. The reduction of church façades and Dutch houses to geometrical schemata is a structural work of search and penetration into the depths of an immutable, mathe-

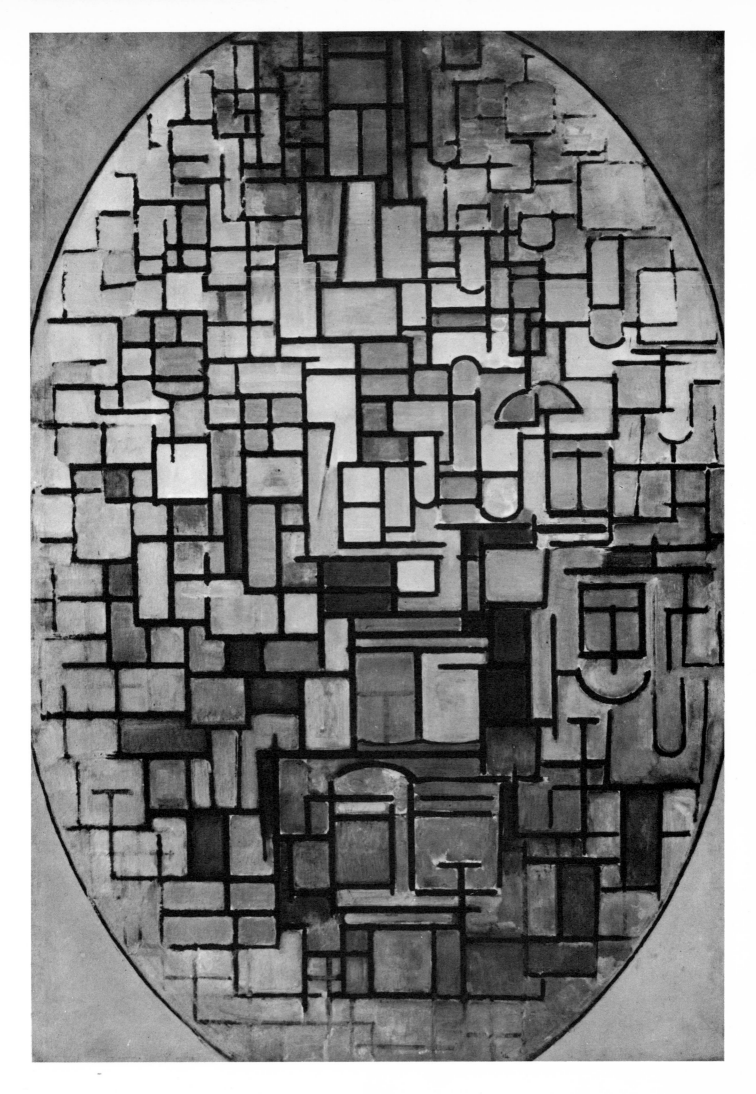

matical reality ('the great internal law') which is hidden behind appearances, although it can be seen through them. Architectural order helps to reveal this reality and to define it.

Architectural elements influenced Mondrian's thought in two principal ways: firstly, emblematically, as symbols of the metropolitan environment and the myth of the modern city, and secondly, theoretically, as the science of proportion and the methodology of planning. With the creation of primary forms within a modular context and with a structural skeleton of invariable signs, the structures of the pictorial vision are superimposed on the architectural vision, becoming an anticipation of architecture, a plan on the level of the logic of forms.

The reduction of the image on the basis of the experience of architecture is a variation on the theme of the identity of objects, since any particular, brought back to the universal logos which is unique, can only be equal to itself. This explains the recurrence of the structural module which is figuratively realised through the introduction of the modular element, the intersection of verticals and horizontals and the consequent commitment to the right angle (see the drawings for the *More and Less* series, and the

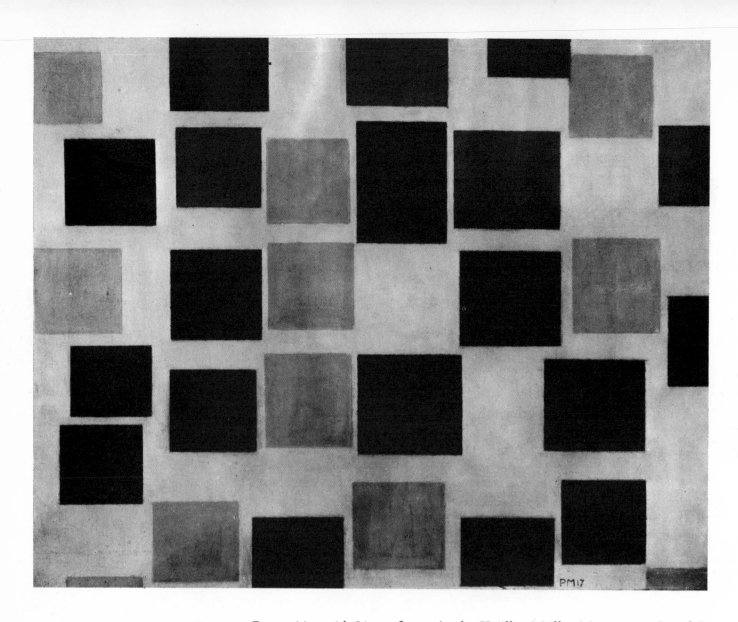

Fig. 22

24 *Composition with Colour Planes*
1917, oil on canvas
$18\frac{3}{4} \times 24$ in (48×61 cm)
Boymans Museum,
Amsterdam

Composition with Lines of 1917 in the Kröller-Müller Museum at Otterlo).
The right angle is understood as the universal 'positional relation', pure and
absolute. Here we should also note that Shoenmaekers wrote: 'The figure,
which objectivates the conception of a pair of entities of the first order, is
that of absolute rectangular construction: the cross.'[25] Mondrian describes
it in this way: 'Equilibrated relations are expressed in nature by position,
dimension and value of natural form and colour; in the abstract they manifest
themselves by position, dimension and value of straight lines and rectangular
planes of colour. In nature we can observe that all relations are dominated
by one primordial relation: the relation of one extreme to the other
extreme. Abstract representation of relations manifests this primordial
relation by the duality of position, in rectangular opposition. This relation
of position is the most equilibrated, as it expresses the relation of one
extreme to the other in absolute harmony, comprising all other relations.
When we come to see these two extremes as a manifestation of the interior
and the exterior, we become aware of the fact that in Neoplasticism the
link between spirit and life has not been broken – we will come to see that
Neoplasticism is no denial of full life; we find that the dualism of mind and
matter is reconciled in Neoplasticism.' This pure spatiality is objectified in
the work of art in an act which is moral as well as aesthetic, which sublimates
and purifies. 'Everything has a cause, but we do not always recognise it. To
know, to understand, is happiness,' Mondrian wrote in 1915. In the same
year, in a letter addressed to van Doesburg, he said, with reference to the
More and Less series: 'As you see, it is a composition of vertical and horizontal
lines which, abstractedly, will have to give the impression of rising up, of

25 *Beeldende Wiskunde*, quoted by Jaffé, *op. cit.*, p. 59.

38

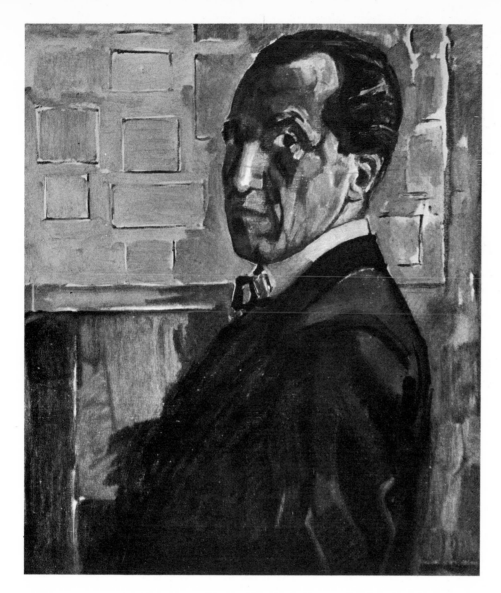

25 *Self-portrait*
1918, oil on canvas
$34\frac{1}{2} \times 28\frac{3}{4}$ in (88×73 cm)
Slijper collection,
Blaricum

height. The same idea was meant to be conveyed in cathedral construction formerly. As in this case the manner of expression (*de Beelding*) and not the subject-matter should express this idea, I did not name this composition. The abstract human mind will have to receive the intended impression by its own means. I always confine myself to expressing the universal, that is, the eternal (closest to the spirit) and I do so in the simplest of external forms, in order to be able to express the inner meaning as lightly veiled as possible.'[26] This cathartic and mediating function of art which moves us to contemplation procures for us the means of salvation by eliminating the tragic from life. Mondrian did not, however, allow himself to be hypnotised by Mallarmé's concept of the profanation of the blank surface on whose virgin expanse vertical and horizontal lines are deposited, almost automatically, although in a rarefied rhythmic pattern. His intuition was always guided by an intense critical attitude which allowed his hand to trace unhesitatingly the solid foundations of form.

His technique has nothing mystical about it; it is the systematic elimination of the enclosed form and of the indeterminate and ambiguous form (such as the curve and the circle), and of non-primary colours. It raises the image above particular, relative morphology, and brings the work of art to the limits of the ineffable. It is a rigorously constructive and selective activity which involves the systematic elimination of any Impressionist, Secessionist or Cubist residue. Mondrian's image of multiplied elements represents the extreme experimental amplifications of Cubism passed through the filter of architectonic exactitude. The Neoplastic invention was to be founded on the technique for building in space and time. 'Of the many possible directions,

26 Quoted by Jaffé, *op. cit.*, p. 12.

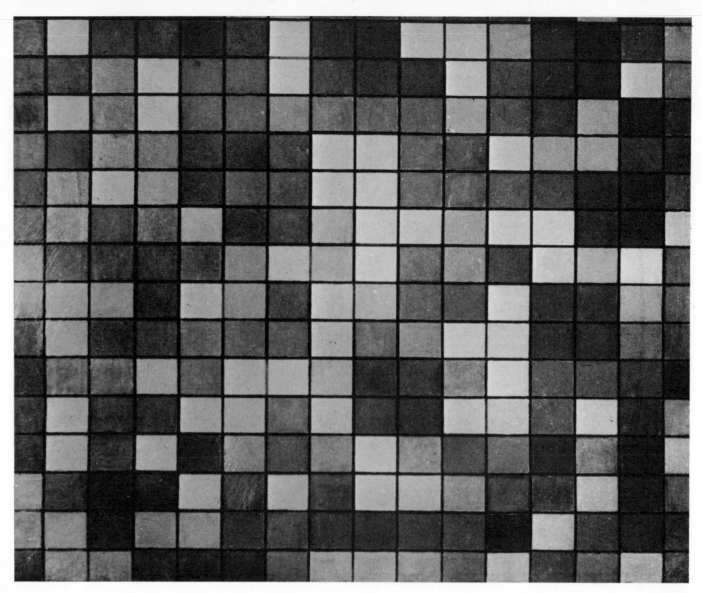

26 *Chequerboard Composition with*
Bright Colours
1919, oil on canvas
33¾ × 41¾ in (86 × 106 cm)
Gemeentemuseum,
The Hague, Slijper loan

only the two fundamental ones are retained – the horizontal and the vertical: of the many possible degrees of brightness, only the three fundamental values – black, grey and white.'[27]

Mondrian was to call this 'plasticity', and it was not reserved for painting only: 'All the arts tend to follow the plastic aesthetic of the relation which exists between the individual and the universal; the subjective and the objective, nature and mind; all the arts are therefore without exception, plastic.' Poetry should strive for a 'plastic sound', that is, for a new type of word 'with a new character and without limitation either as sound or idea'.[28] Music should abandon naturalism in favour of tones produced by machines without individual participation, to be heard as pure sonorous form. Film should have no narrative basis (as in Richter's experiments), and dance should be 'abstract dance'.

Mondrian's beliefs were so rigid and dogmatic that in 1924, as we have seen, he ceased to contribute to *De Stijl* magazine when van Doesburg adopted the oblique line in preference to the vertical and horizontal line in his compositions.

The fundamental condition of Mondrian's aesthetic method centred on the certainty of finding the condition of 'plasticity'. The Romantic, problematic conception of art sees it as the reflection of the condition of uncertainty of the human spirit and uses it to investigate the mystery of existence (this in some ways persisted in Mondrian's own work until about 1917). For this attitude Mondrian substituted a 'certainty': the new plastic

27 G. Schmidt, Preface to M. Seuphor's *Piet Mondrian, op. cit.*, p. 9.
28 See *Il Secondo Manifesto di De Stijl*, quoted in M. De Micheli, *Le avanguardie artistiche del '900*, Milan, 1959.

art 'is characterised by security, it does not ask questions, it offers a solution'.

After Calvinism and Theosophy came the birth of Neoplasticism. 'Human consciousness firmly pushes back the unconscious and expresses itself in art in a way that, by creating equilibrium, excludes any uncertainty. The tyranny of the tragic is over.' Between the years 1919 and 1938 Mondrian developed in depth an almost unique and unequivocal image which achieved a total emotive reserve, an infallible certainty which was to remain intact in its serene ontology until the years in New York, when his art, turning back to the Paris compositions of 1917, took a new and disturbing turn. The inflexible adherence to a single theme is not the sign of limitation; indeed, in confirming the simple fact that art belongs to the sphere of ethics, and hence of freedom, it is a sign of complete liberty; the liberty of number and calculation in a mathematical temperament; the liberty of solving the contradictions of phenomena on the logical plane with an equation. In short it indicates a moral freedom which is the antithesis of the law of necessity in the natural world.

Mondrian's systematic account of his theories was published in 1920 in Paris by Léonce Rosenberg's *Galerie l'Effort Moderne* under the title of *Le Néo-Plasticisme*. This work was reprinted five years later by the Bauhaus with the title *Die Neue Gestaltung,* a term which emphasised the 'formative' character of the image, that is, the psychological difference between form and formation.

27 *Composition with Red, Yellow and Blue*
1922, oil on canvas
$16\frac{1}{2} \times 19\frac{3}{4}$ in (42×50 cm)
Stedelijk Museum,
Amsterdam

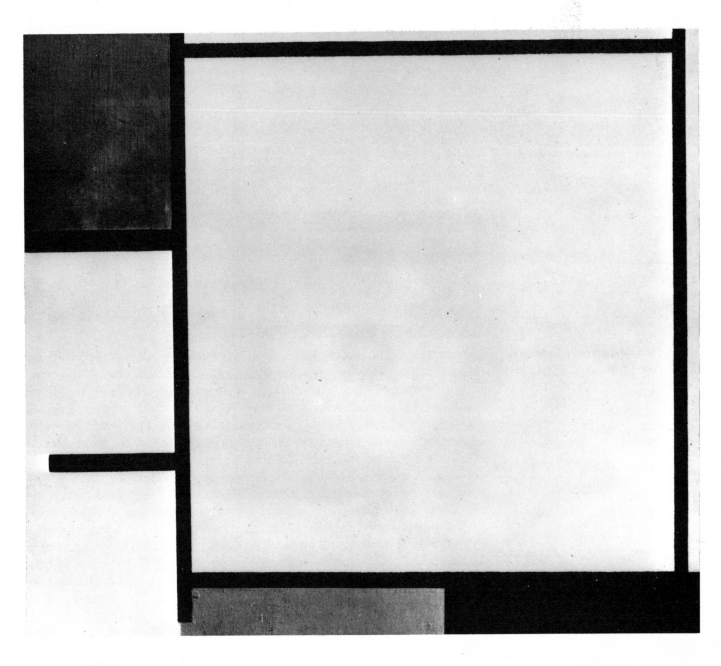

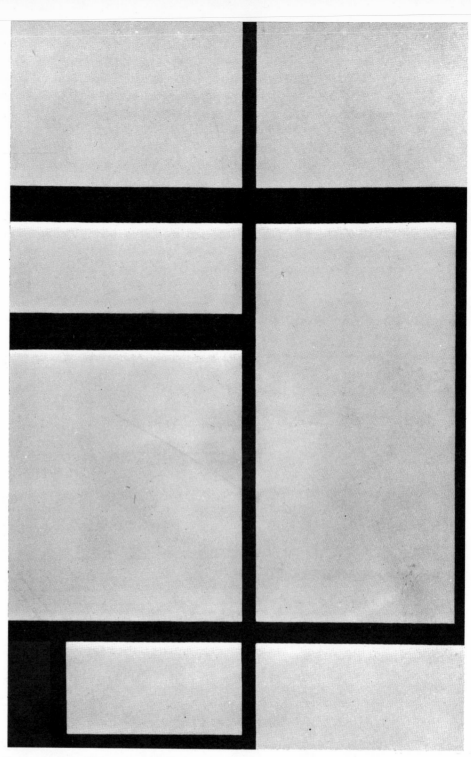

28 *Composition with Red, Black and White*
1931, oil on canvas
$31\frac{3}{4} \times 21\frac{1}{4}$ in (81 × 54 cm)
Charmion von Wiegand collection, New York

The Phenomenology of Neoplasticism

Pl. 24, Figs. 23, 24

In 1917 Mondrian executed a series of compositions of 'coloured surfaces' on a white ground, which are a development of the 'architectural' compositions of 1914. Sometimes small areas of dark colour emphasise the plastic quality of the coloured rectangles. In those cases the image presents a figural connection with the formative arrangement of the *More and Less* series. His experiments are focused on the rhythm of the image, but are still, however, of the Suprematist type, committed to a figurative method through chromatic surfaces which recall the technique of collage.

In 1918–19 the distinction between figure and background disappears, and the entire surface of the picture is organised as a single visual entity, or is covered with absolutely regular squares in various colours, or with a composition of vertical and horizontal lines which intersect to form squares and rectangles. The first lozenge-shaped pictures appeared in 1918; their rhythm was achieved by means of a grid pattern, which also included the diagonal with grey lines of varying intensity. In other experiments the image is based on the horizontal and vertical line with various combinations of the right angle, whose accentuations minimise the modular progression. In

these works it can be clearly seen that the planes imply the importance of the outline plan; they are the result of the successive abolition of the diagonal and the symmetrical grid structure, the rhythm of which, however, is still present in the arrangement of spatial divisions. The first plastic formulations of the principle of asymmetry, which held that equilibrium is reached through equivalences (the sixth general principle of Neoplasticism defined in 1922, 'All symmetry shall be excluded') also belong to this period. The colours show shadings and gradations; they define the form and the space.

By 1920 Mondrian was organising his colour surfaces according to the rules of the rhythmic equilibrium of the universal image visible in the asymmetry of lines and planes arranged according to a rectilinear division of the surface. The colour range tends to be lighter, and the colours of the squares and rectangles show gradations of uncertain tonality. This embodies the fourth general principle of Neoplasticism; 'Abiding equilibrium is achieved through opposition and is expressed by the straight line (limit of the plastic means) in its principal opposition, i.e. the right angle.'

In 1921 the compositional method was the same, but a greater emphasis on primary colours and a more precise defining of the linear contours of

Pl. 26, Figs. 25, 26

29 *Broadway Boogie-Woogie*
c. 1943, oil on canvas
50 × 50 in (127 × 127 cm)
Museum of Modern Art,
New York

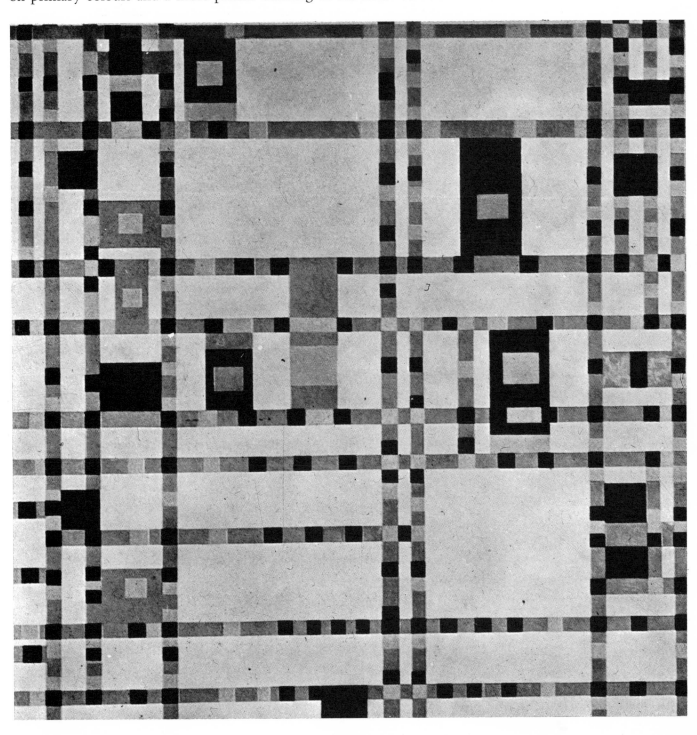

43

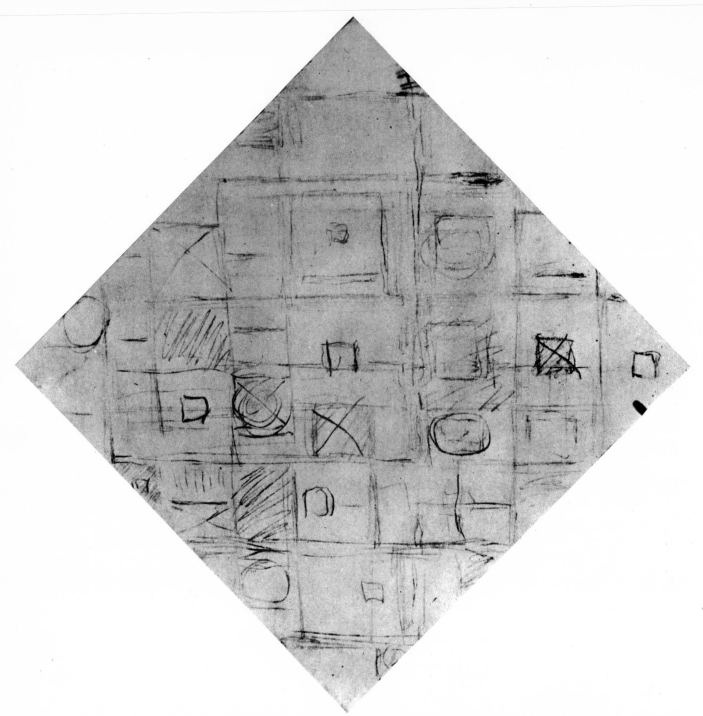

Pls. 27–31

Pl. 33, Fig. 27

30 Drawing for *Victory Boogie-Woogie* 1943–4, pencil 19 in (48 cm) diagonal Harry Holtzman collection, New York

the forms can be observed. There is also a tendency towards an arrangement of the picture which develops its asymmetrical equilibrium in calculated relations of distribution between space and lines. This format leaves large areas isolated and free of lines, making the forms themselves proportionally more dense with a centrifugal movement. Here we see the fifth principle of Neoplasticism: 'The equilibrium that neutralises and annihilates the plastic means is achieved through the proportions within which the plastic means are placed, and which create the living rhythm.'

This tendency was more fully developed in later works (1922–25) which are characterised by the use of a cold, harsh range of colours (particularly the dark blue and the red) and by the predominance of the square, which expands and occupies the greater part of the surface, presenting in relation to a ponderable equilibrium, a crowding of lines at the edges. The same system is applied to the lozenge-shaped series: an almost colourless area of space which projects beyond the confines of the picture in a dimension which escapes from the co-ordinating and defining function of the line, which often, in fact, does not intersect it.

Mondrian was passing slowly from method to system, and logical discipline had eliminated every problem. The inherent rationality of the

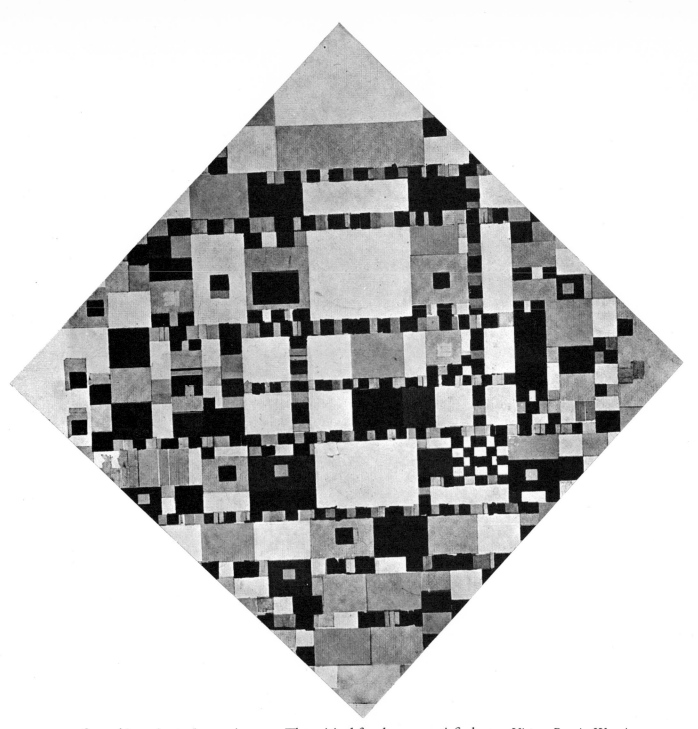

system confirmed its axiomatic consistency. The critical faculty was satisfied with the certainty of a technique that had become almost a ritual of initiation.

Mondrian himself explained and summarised his formative processes in certain passages in his essays. 'In my early pictures space was still a background. I began to determine forms: verticals and horizontals became rectangles. They still appeared as detached forms against a background, their colour was still impure. Feeling the lack of unity I brought the rectangles together; space became white, black or grey; form became red, blue or yellow. Uniting the rectangles was equivalent to continuing the verticals and horizontals of the former period over the entire composition. It was evident that rectangles, like all particular forms, obtrude themselves and must be neutralised through the composition. In fact, rectangles are never an aim in themselves, but a logical consequence of their determining lines which are continuous in space; they appear spontaneously through the crossing of vertical and horizontal lines. Moreover, when rectangles are used alone without any other forms, they never appear as particular forms, because it is contrast to other forms that occasions particular distinction. Later, in order to absolish the manifestation of planes as rectangles, I reduced my colour, and accentuated the limiting lines, crossing the one over the

31 *Victory Boogie-Woogie*
1943–4, oil and collage on cardboard
$49\frac{1}{2} \times 49\frac{1}{2}$ in (126 × 126 cm)
Burton Tremaine collection,
Meriden

45

other. Thus the planes were not only cut and abolished, but their relations became more active. The result was a far more dynamic expression. Here again I tested the value of the destroying of particularities of form, thus opening the way to a more universal construction.'[29]

Pls. 34–36 Between 1926 and 1928 he continued the process of abstraction with the large square. It is possible to distinguish, however, two early signs of a process which was later developed to maturity: the harmonious distribution of space achieved by means of the reduction of the whole surface to two significant images (squares, and horizontal and vertical rectangles) produced by the prolongation of the determining lines; and secondly, the increasing importance given to the lines as the creators of the image. This emphasises the supporting and structural role of line, which no longer has the function of delimiting the geometric figure, because this is no longer closed but is in the form of open spatial divisions. Thus the background again acquires importance, although it is a negative importance. It will almost always be a uniform white and grey – the chromatic definition of space.

Pls. 37, 38 In the years 1929 and 1930 this system was fully and explicitly developed. For the first time, also, differences appeared in the thickness of the lines; this continued to develop up to 1933, by which time the picture was conceived entirely as a counterpoint of lines, sometimes double, enclosing one or two chromatic elements. Form was defined in reds, blues and yellows.

Mondrian had stressed that, 'In spite of its "interiorised" plastic expression, Neoplasticism remains painting.' He was referring to a 'colour-object' which is not subordinate to the rules of form, and is not an attribute of form or its support, but is itself form.

In 1935 the criterion of asymmetry became complicated by 'lines of force' which are also lines of tension with chromatic and formal episodes intensified at the edges. A dynamic equilibrium takes the place of the static equilibrium. The disrupting and coupling of colours led to kinetic-optical effects.

The gradual disappearance of the square, and the format of the picture, showed unusual spatial divisions. Not infrequently one finds compositions
Pls. 29, 40 which consist solely of parallel vertical lines which are not intersected throughout the whole height of the picture, and which stop at the edges without defining any geometric figure. The compositions increasingly obey the inner requirements of rhythm. The space vibrates as if from behind a grille.

In 1940 Mondrian translated the appearance of New York into a blaze of colours, shattering the image into many new forms. In these paintings the line is composed of a multiplicity of little squares; the composition no longer has a centre and the single viewpoint is suppressed. The image no longer consists of a single plane identified with the surface of the picture, but is developed on overlapping planes which recapture with an increasing raw excitement an almost naturalistic and objective dimension of space
Pl. 47 (*New York City*, 1942). The planes are not, however, stepped back in depth, but superimposed on the surface, like the weave of a fabric or strips of coloured paper placed on the surface in successive layers (*New York City No. 2*, 1942).

Mondrian at this stage seemed almost to suffer from a *horror vacui*, his designs no longer demonstrate the infallible results of his system. Black disappears, the continuous line disappears; an intense sun-yellow, like Van Gogh's, dominates, together with red. The optical effects of visual dynamism are intensified, and the spatial divisions rely for their impact more on sensation than on logical perception.

The American epilogue We have seen that Mondrian's compositions between 1920 and 1938 show a progressive mastery of Neoplastic forms elaborated through synthesis according to exact variations of the minimums of quantity. They do include a dimension of time, but this, until the New York period, is not related to

29 Piet Mondrian, *Plastic art and Pure Plastic Art*, New York, 1945, p. 13.

phenomena (except for the brief introduction of the years 1917–19) but is rather a kind of immobile metaphysical time, immutable except through quantitative minimums. From 1938 to 1944 the image shows an intensification of formal relations; thus in the first decade colour develops an important role in the economy of the image. In the works of 1930 and onwards, apart from some episodic exaltations of red and blue, the pure expression of space is delineated in intersecting vertical and horizontal lines which, on a colourless spatiality, mark the ultimate confines of utopia, their projection in a space which has become empty. Perfectionism has suspended the artist above the historical void.

Pls. 43–47, Figs. 29–31

Mondrian's works of the New York period, particularly the famous *New York City, Broadway Boogie-Woogie* (1942–3), and the unfinished *Victory Boogie-Woogie* (1944), break up the frozen immobility of his discarnate logos. The space is fragmented, the lines vanish, the plan is realised, the planes multiplied; life erupts into the canvas with all its contingent and sensible meaning. It is not the starry sky which causes this delirious fragmentation of the image, as it was in the *Plus-Minus* experiment, which comes to mind as a comparison, but a new definition of the city; a pragmatic and terrestrial definition in which the rational schema does not succeed in conditioning the existence of the individual; where horizontal does not always harmonise with vertical; where 'existence' upsets 'being' and there is no rule beyond the insistent rhythm of reality.

Pl. 47, Figs. 29–31

The artist now found himself submerged in a world which he had always considered as the front line of progress: a world in which the new imposed itself with preremptory force. As he wrote in 1942: 'Plastic art must move not only parallel with human progress but must advance ahead of it.'

From the dizzy heights of a total view of being as the emblem of the rational consciousness of the Western world, Mondrian turned his gaze lower, towards a world that is the direct projection of praxis. The geometry of New York, even seen from above, vibrates with life, with pulsations of light, with infinite and contradictory possibilities within the crowded planimetric layout of the urban networks which obstruct and hem them in. The mystical, deserted geometry of church façades and the canals of Holland was replaced with the secular, earthly and overpopulated geometry of the urban condition. The soothing horizontality of the luminous sea at Scheveningen was contrasted with the dizzy verticality of the sky-scrapers of Manhattan and 59th Street, as was Calvinist psalm-singing with the syncopated rhythm of the boogie-woogie.

The sad discovery that the metropolis is not *civitas hominum* brought to Mondrian a loss of happiness and a bitter recognition of the ever-present tragic disequilibrium. Mondrian wanted to be part of history; instead being came up against existence. And he discovered then that 'Where there is no history, reason becomes lucid madness'.[30]

In 1914 he had written that happiness lay in immobility, the absence of activity. His final European achievement had been, in fact, an immobile, dazzled contemplation; a splendid and systematic aesthetic insight into being and exact beauty. But now the rational conquest of the historical consciousness of Europe, the immutable ontological order that was the object of all his researches, had become a trap, a restless delirium of changing meanings. Perhaps his geometry did not, after all, reflect the rational structure of consciousness, but was nothing more than an expedient for escaping from the relentless dialectic of history. It became increasingly a reflection of technological alienation and scientific anguish; it became itself, conscious anguish. Argan has written, 'It is only a step from the crazy geometry of the *Broadway Boogie-Woogie* to the refulgent and sublime desperation of Pollock.'[31] Mondrian has registered lucidly the crisis of European consciousness confronted with the pragmatism of American civilisation. He died before he could lose completely the sense of that consciousness.

Fig. 29

30 G. C. Argan, *Salvezza e caduta nell'art moderna*, Milan, 1963, p. 63.
31 *Op. cit.*, p. 85.

Colour plates

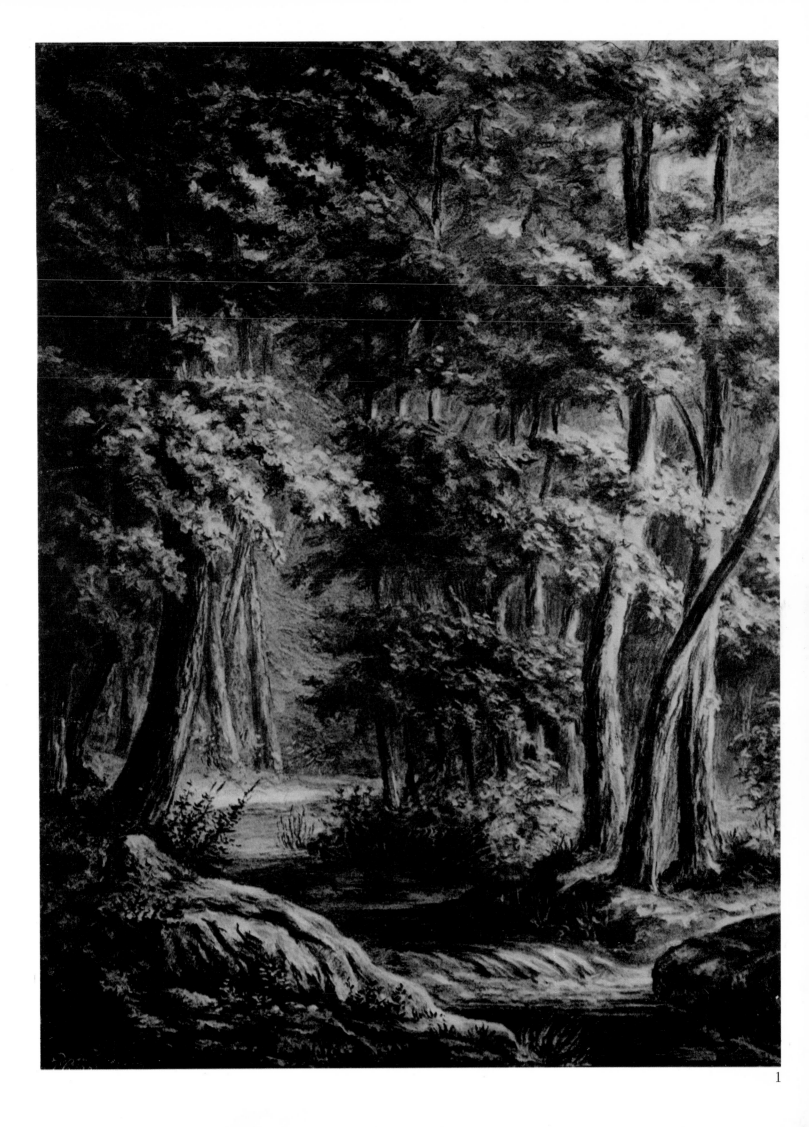

1

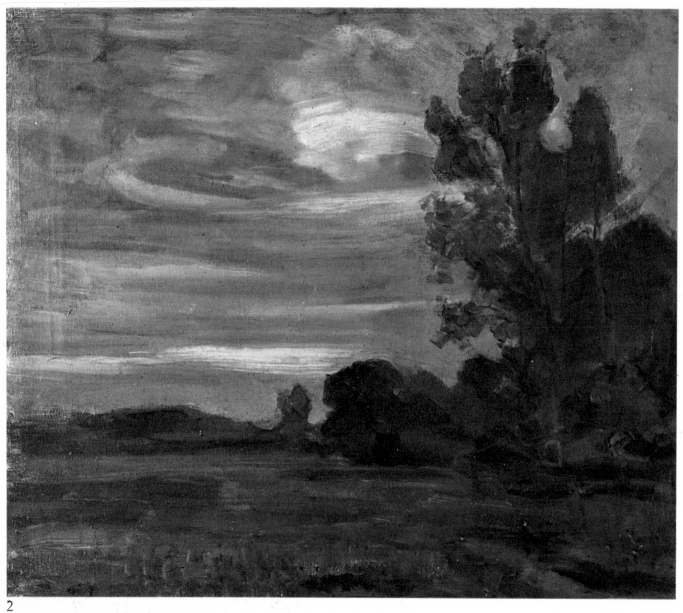

2

3

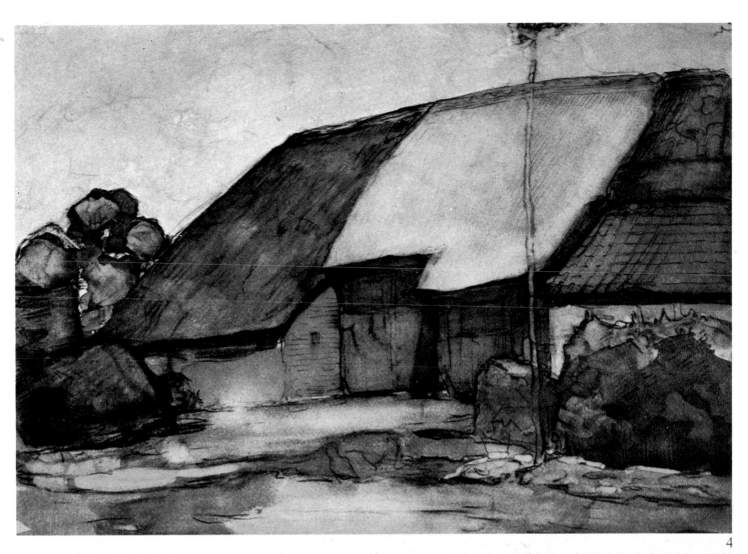

4

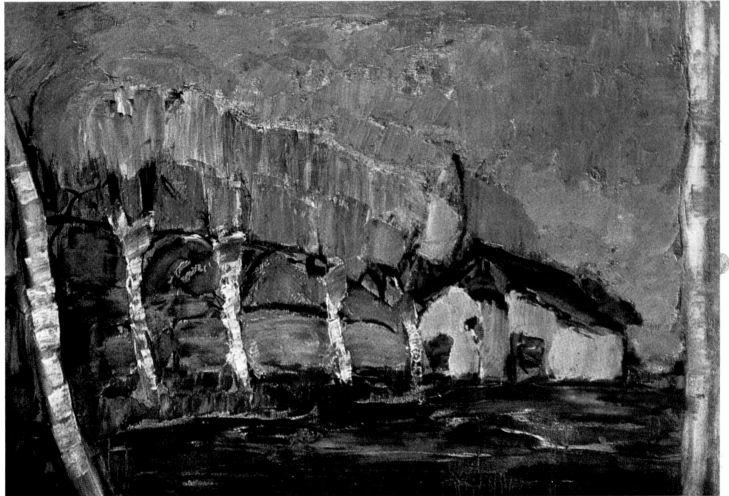

5

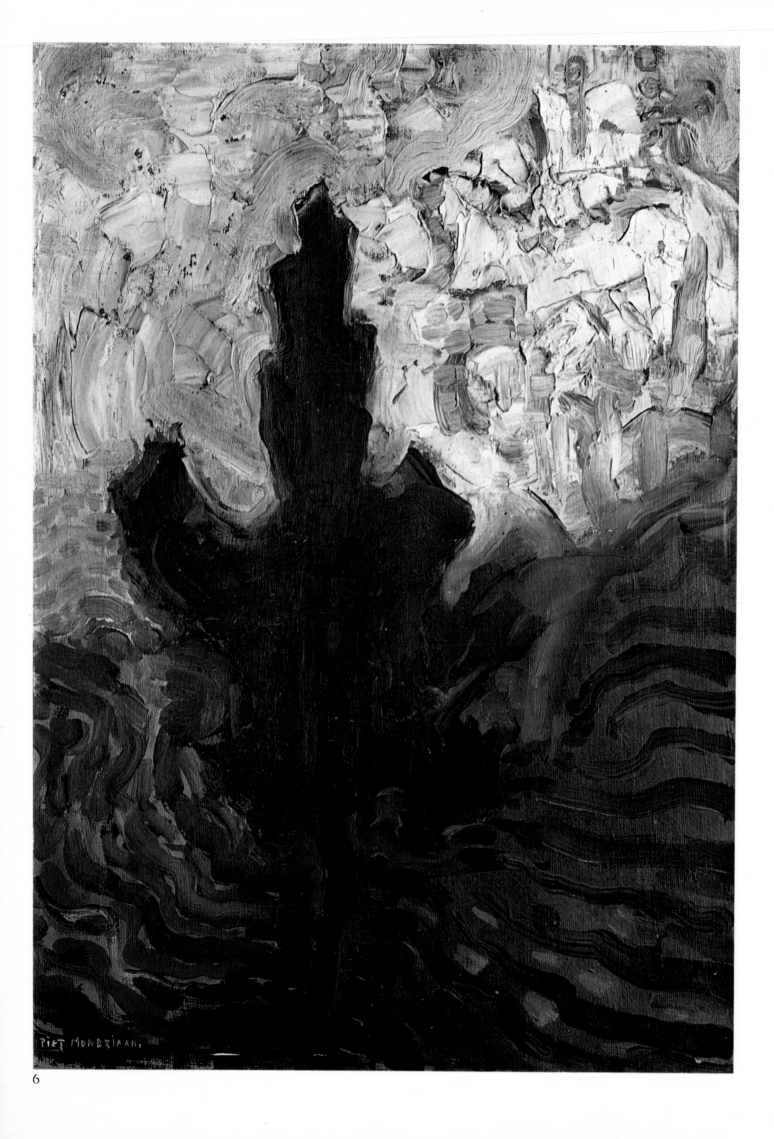

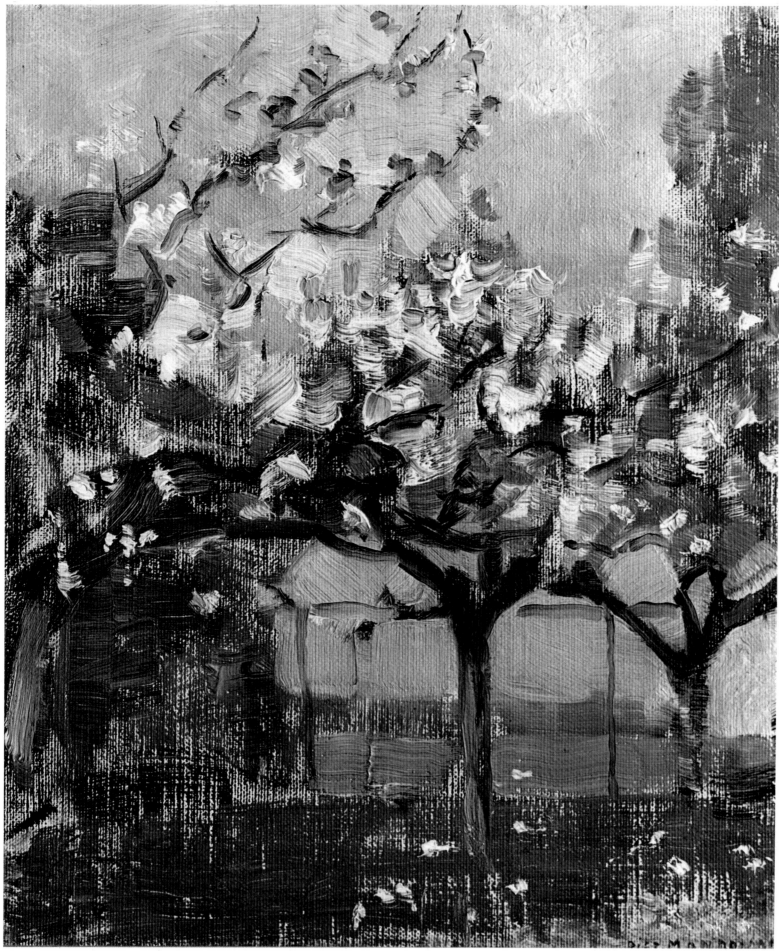

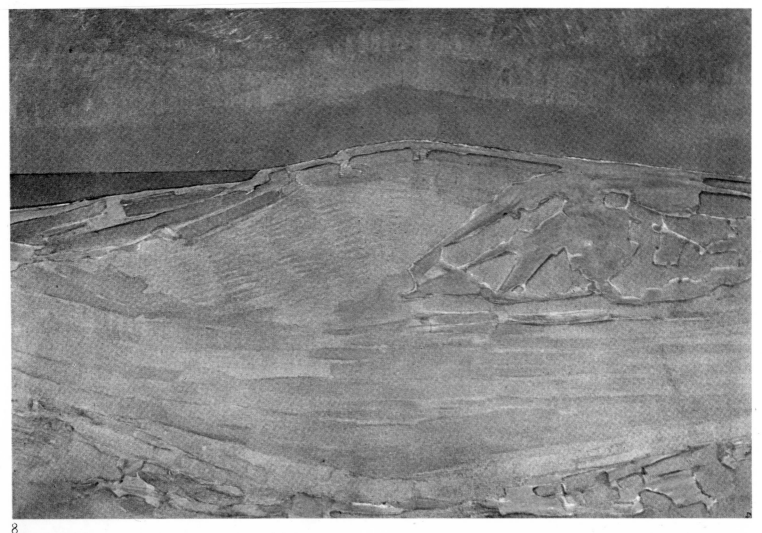

8

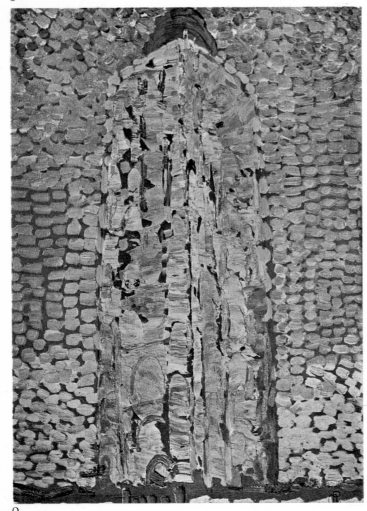

9

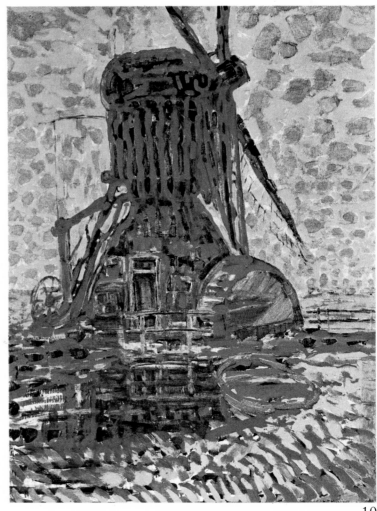

10

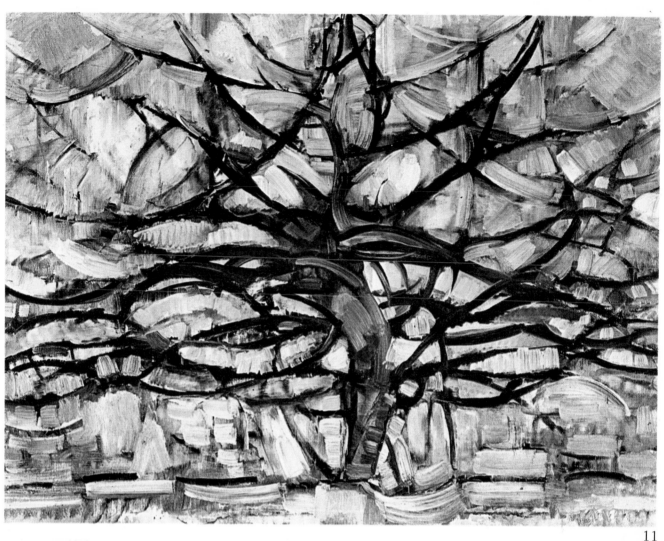

11

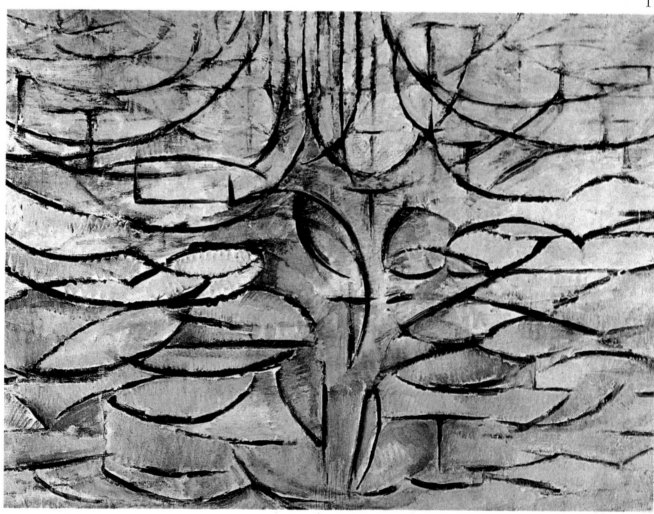

12

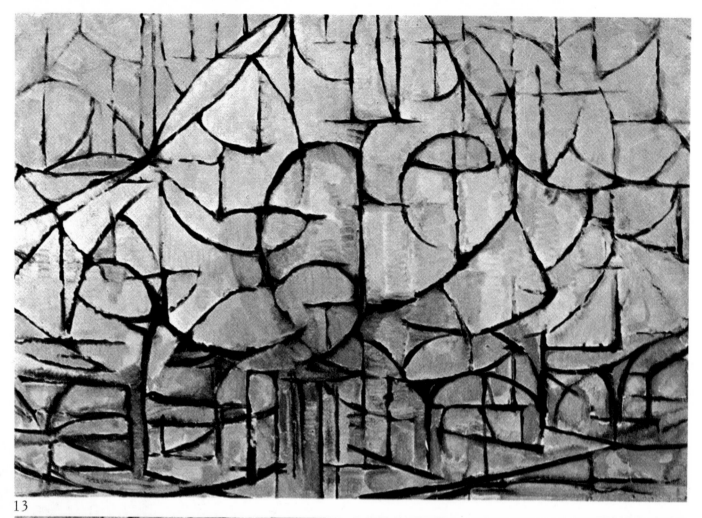

13

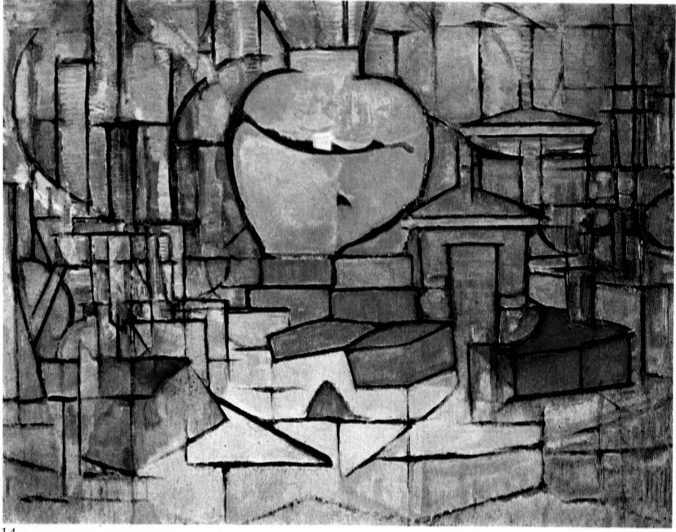

14

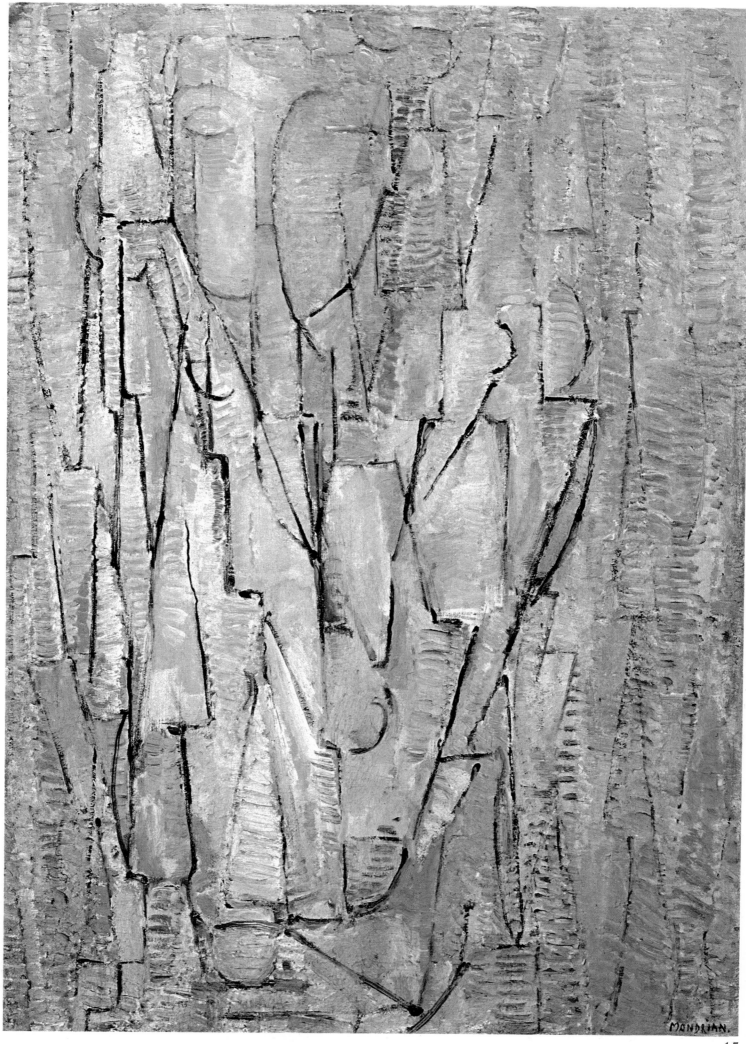

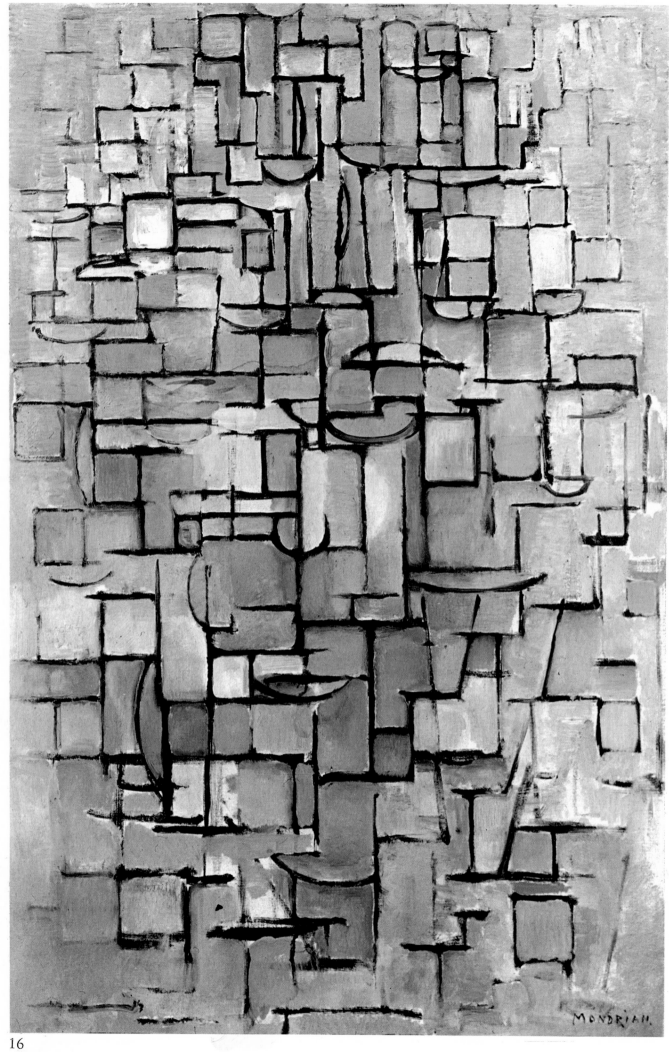

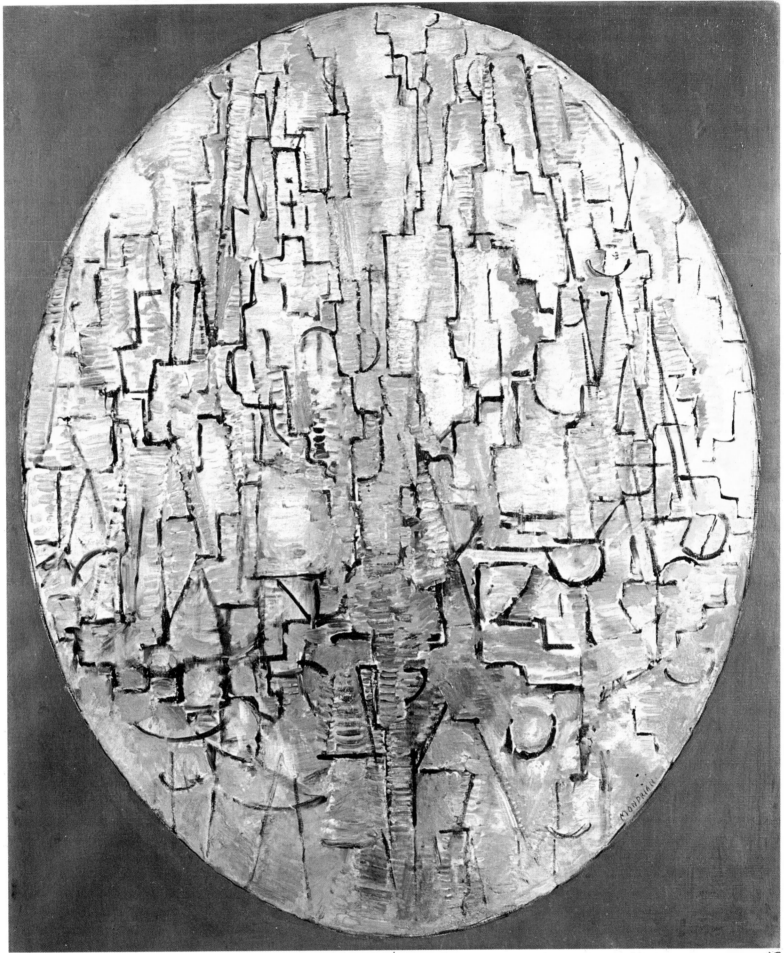

17

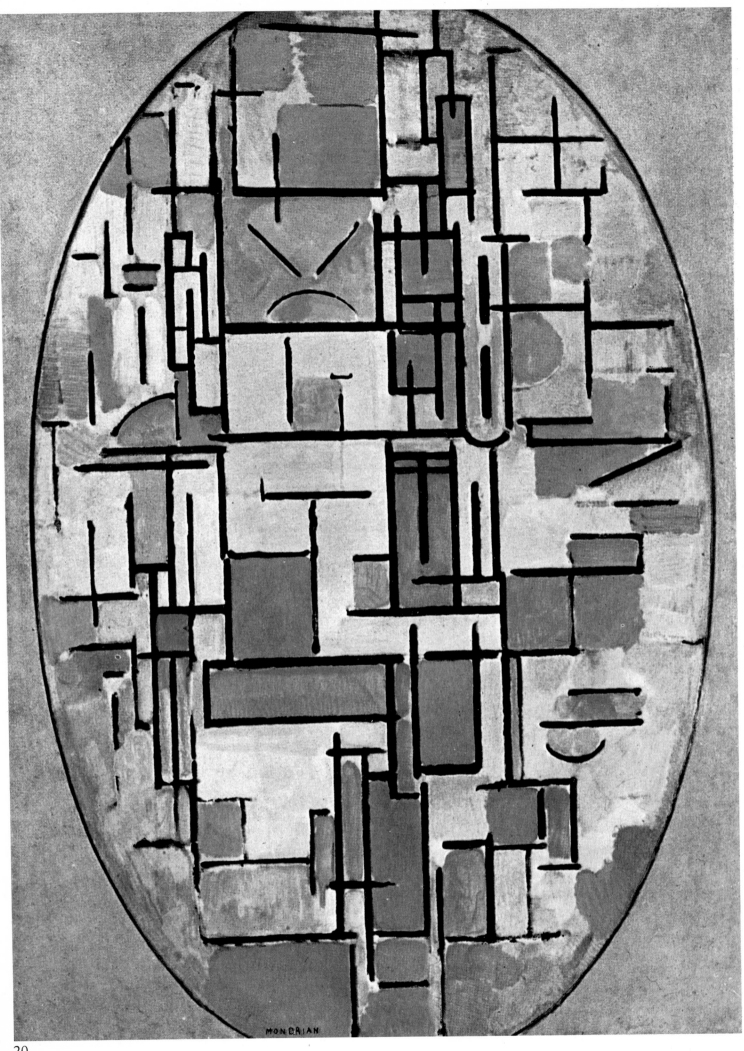

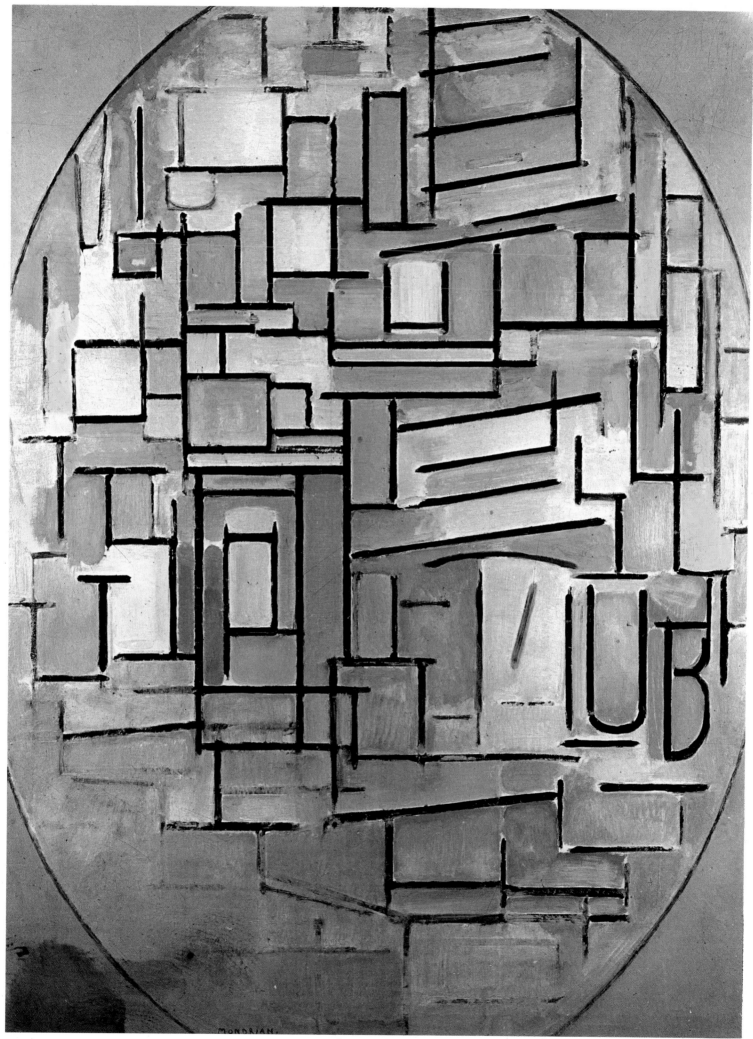

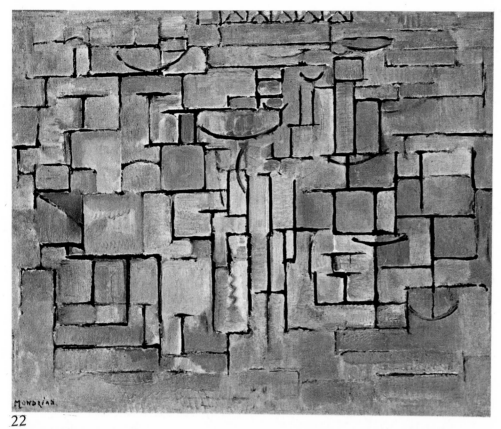

22

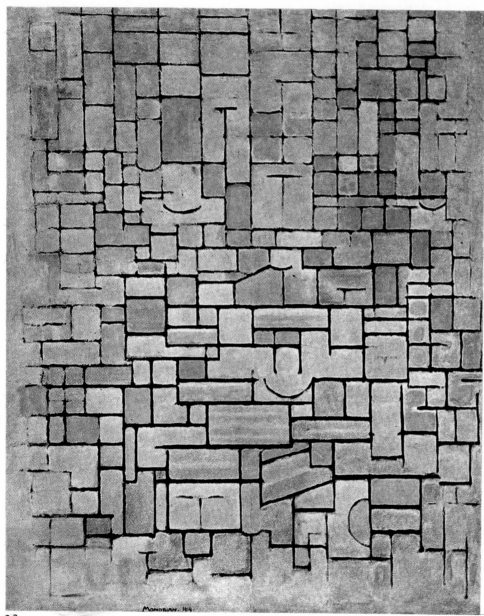

23

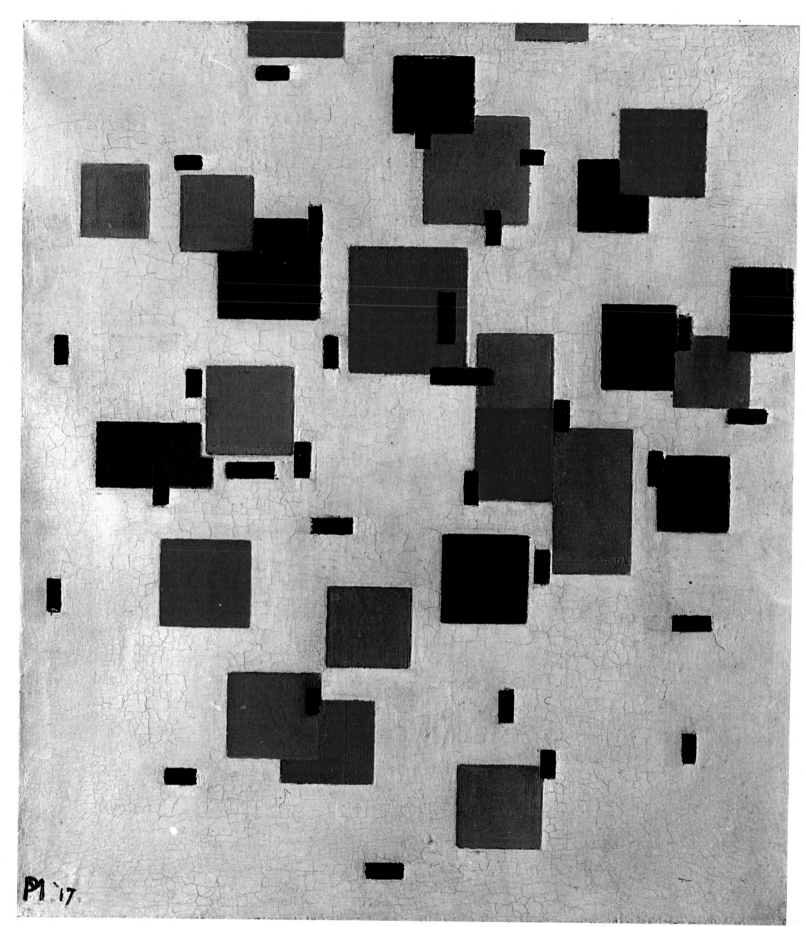

PM '17

24

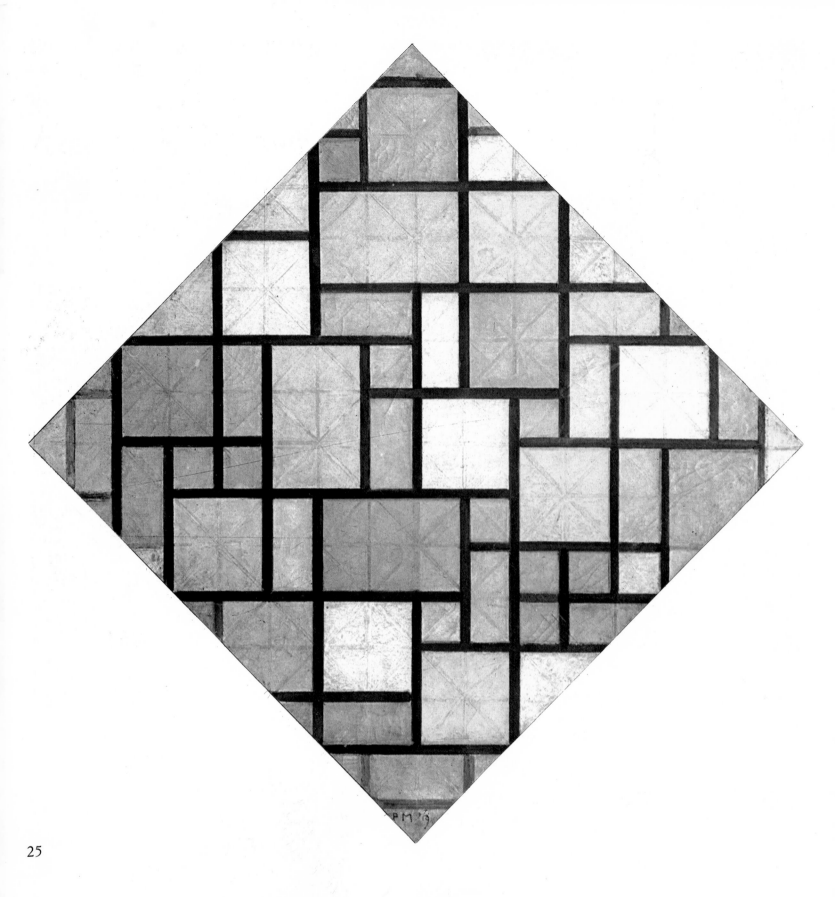

25

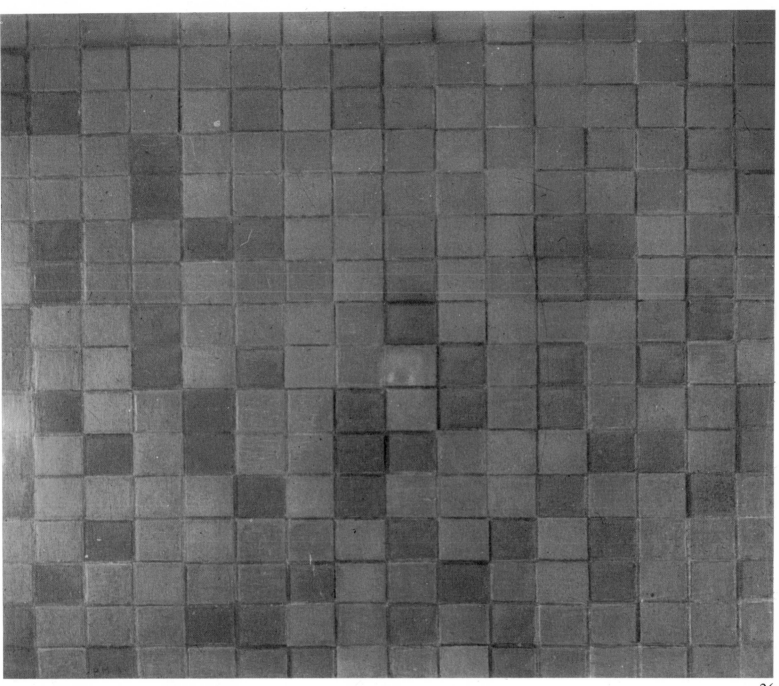

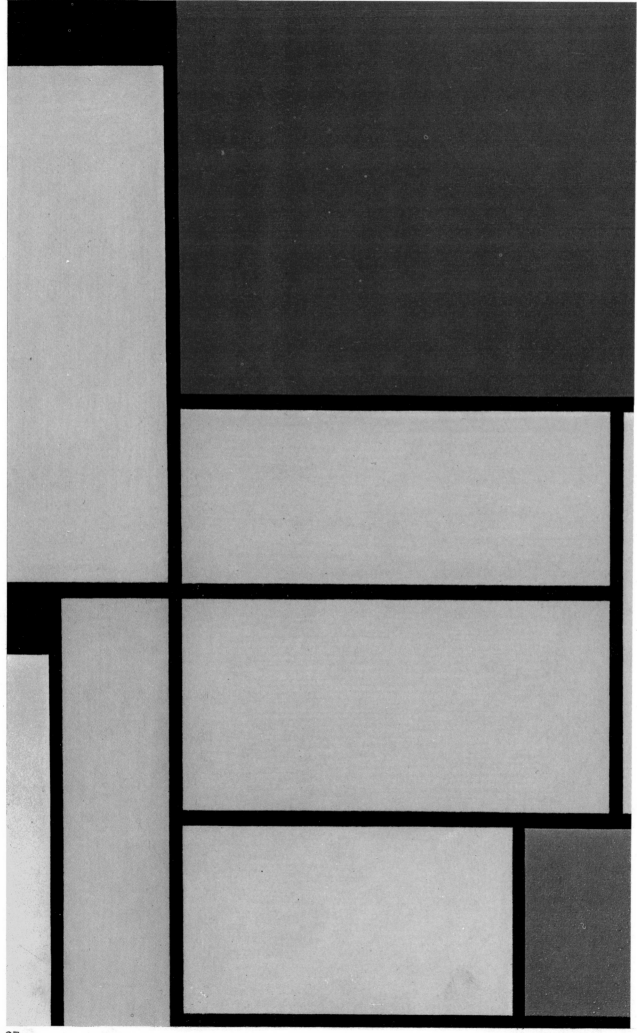

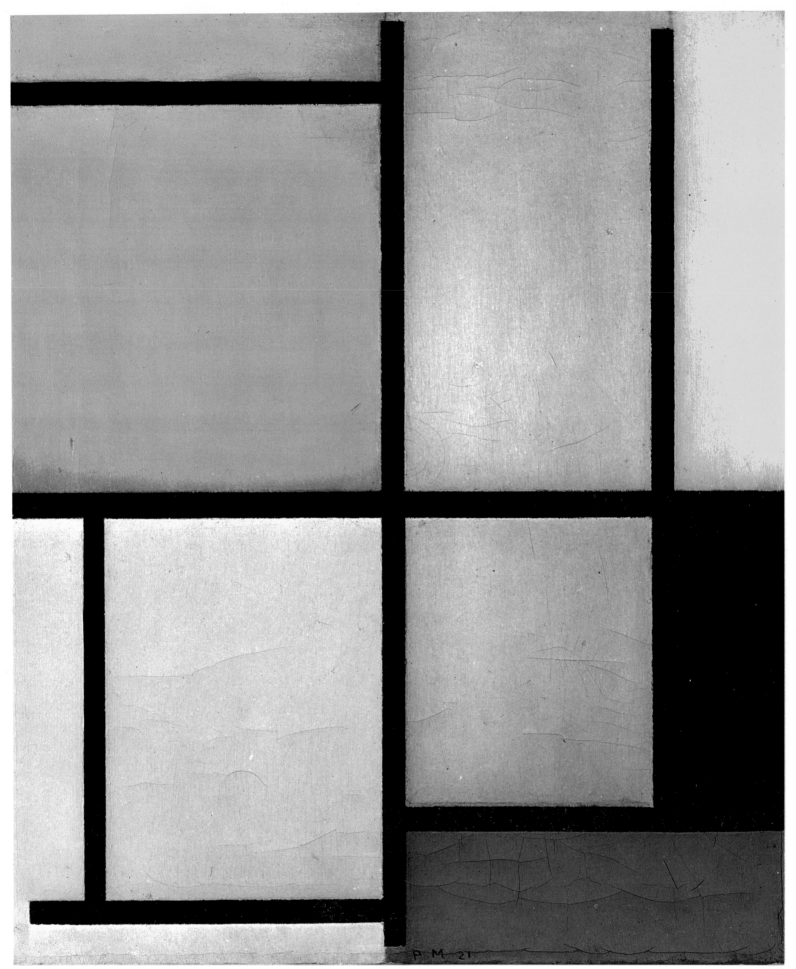

29

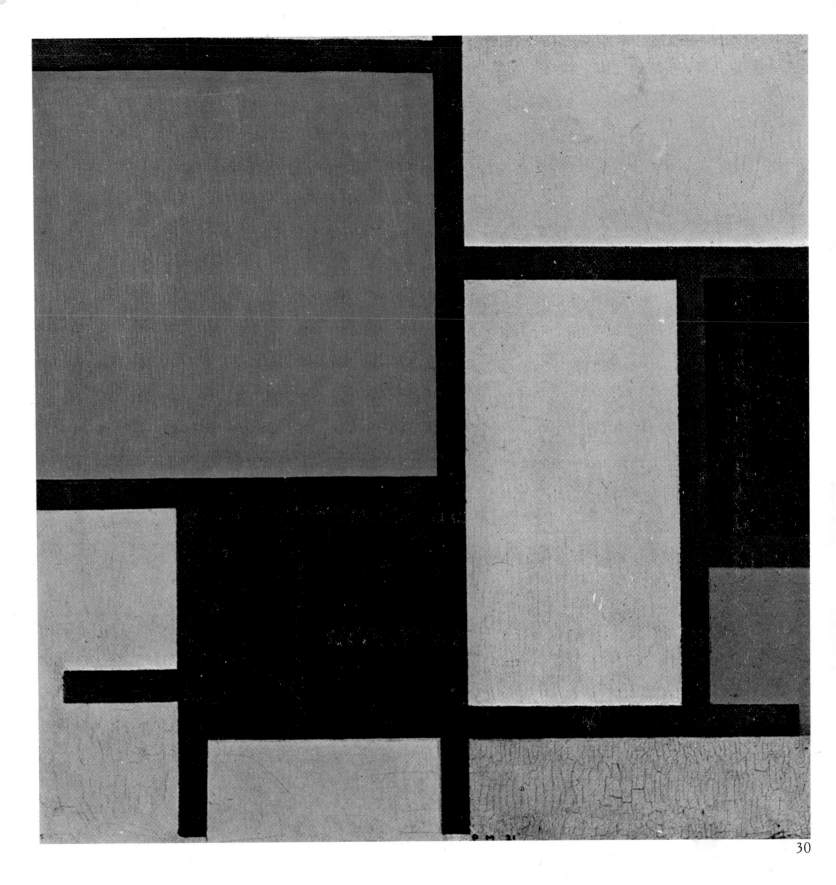

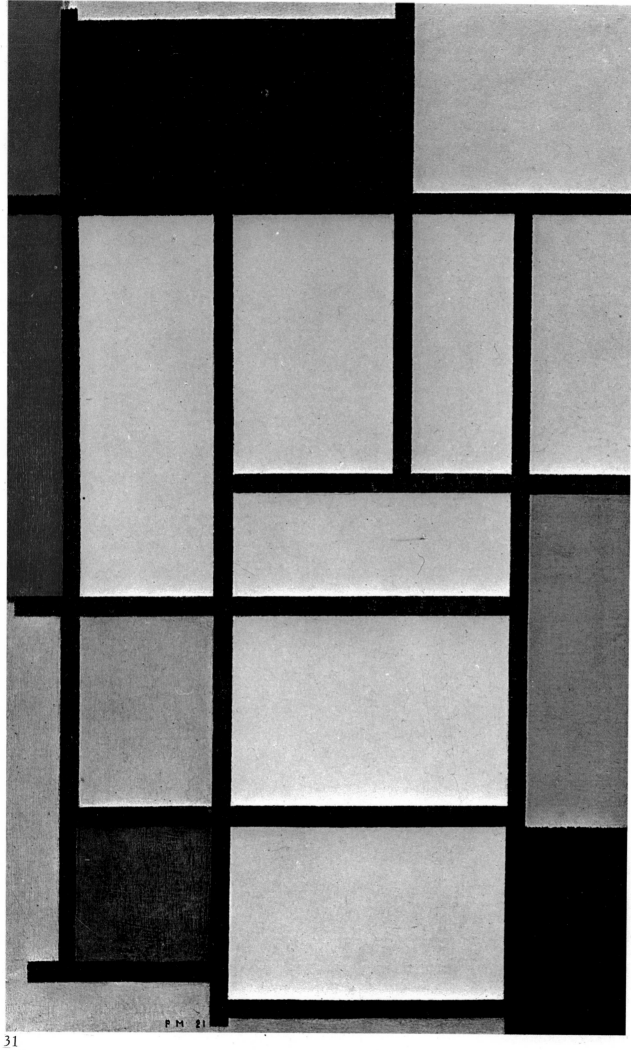

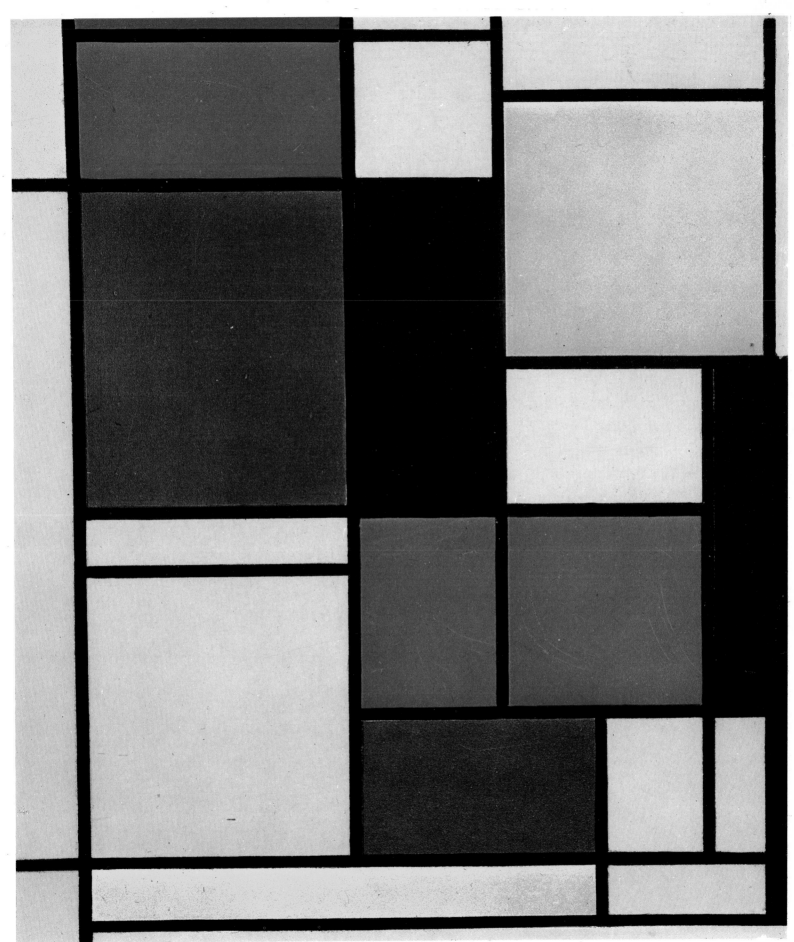

32

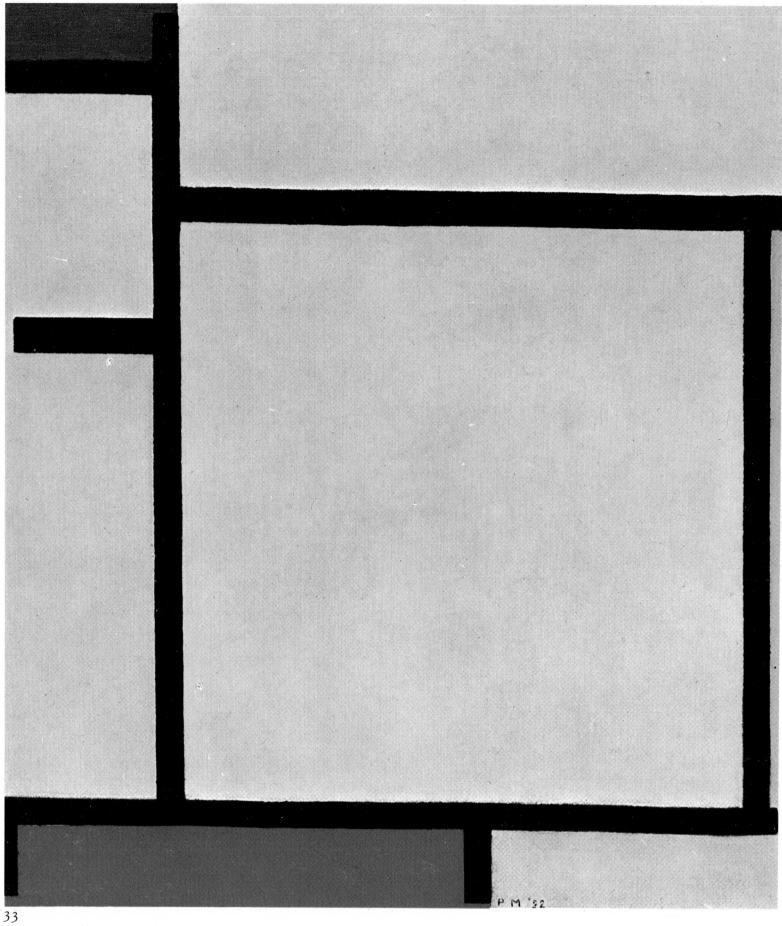

33

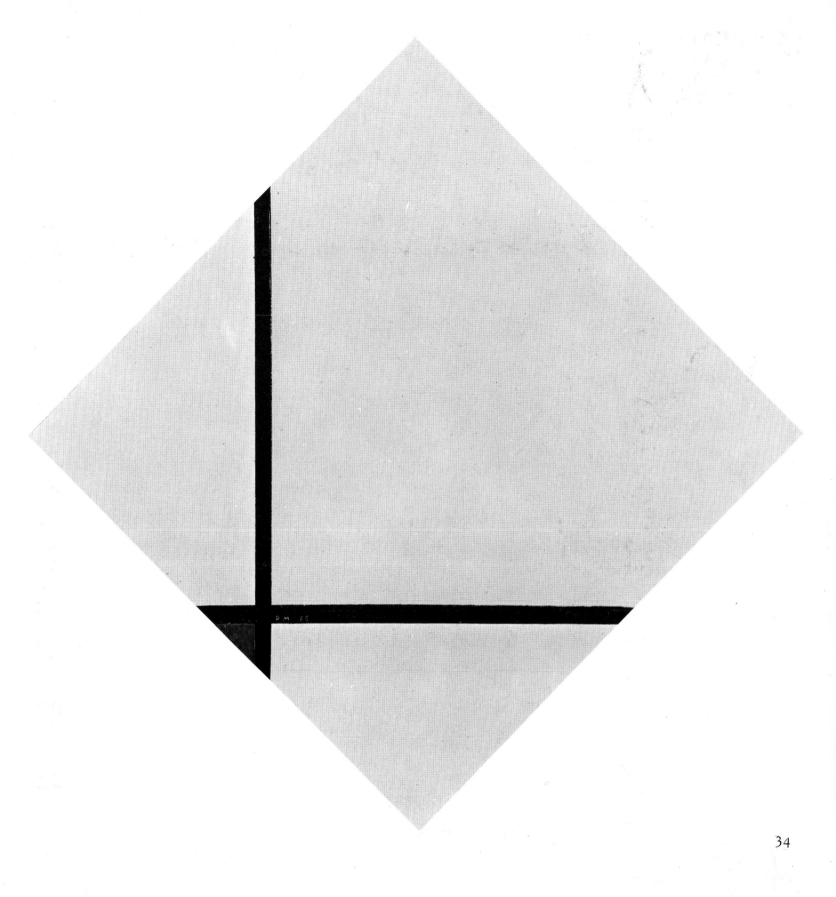

34

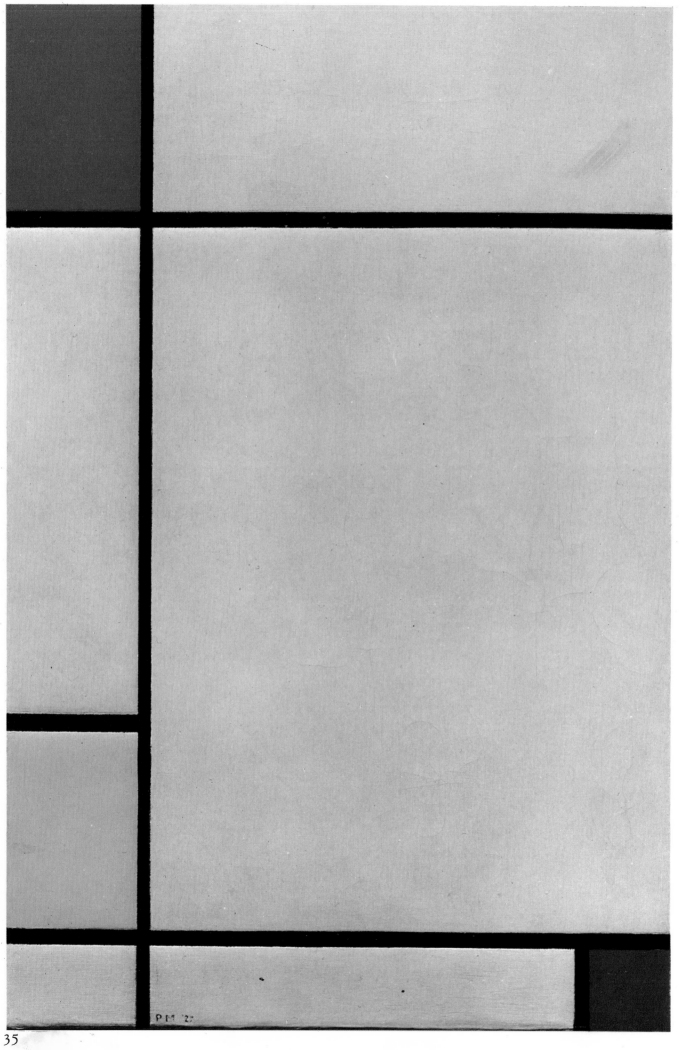

35

T E X T U E L

îlot physique Seuphor sous l'aile de Mondrian
sous les drapeaux sérieux du Néo-Plasticisme
battant le pavillon très pur

échappée belle de l'art
enfin mesure d'hygiène
ralliez-vous tous au pavillon du grand secours
du grand sérieux quand nous serons mieux éclai[rés
et disparaisse la flore sous le regard néo
et cessent les éboulements

l'îlot physique sort des cavernes
il ose construire dans le clair
il lève la tête
où il n'y a que le grand bleu
et le grand gris et le grand blanc
et le grand noir et le soleil tout feu
suivi des synonymes bonheur sagesse connais-
et de la joie... [sance
qu'il ne faut pas confondre encore

mais il fallait y penser si j'ose dire
être déjà et non choisir et choisir bien quand-même
mais il fallait prendre contact
marcher longtemps et sous le juste signe

M. Seuphor

16 mai 1928

P. M

36

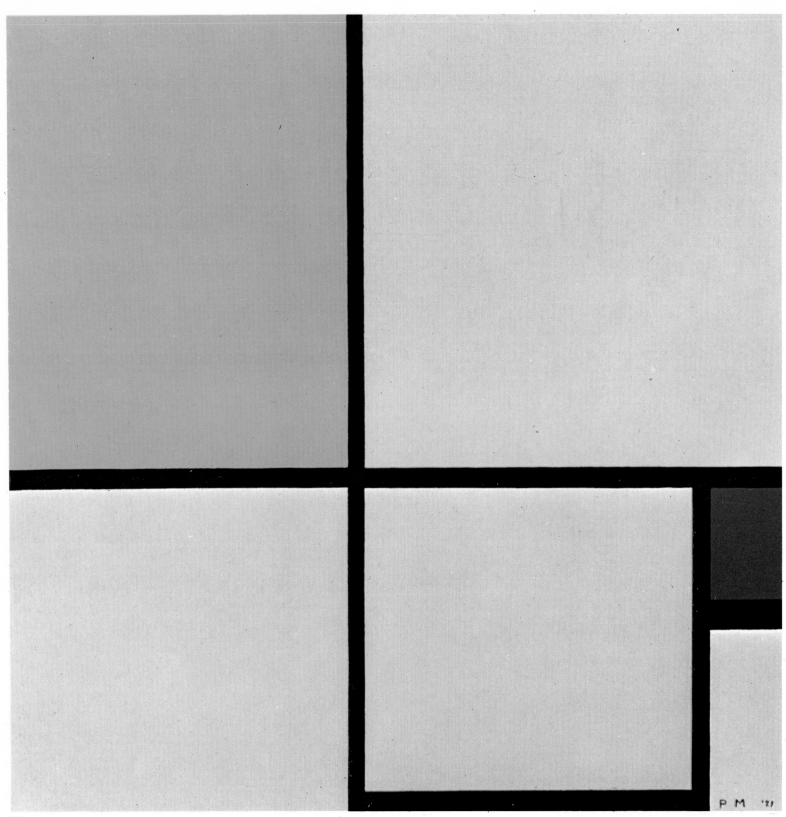

37

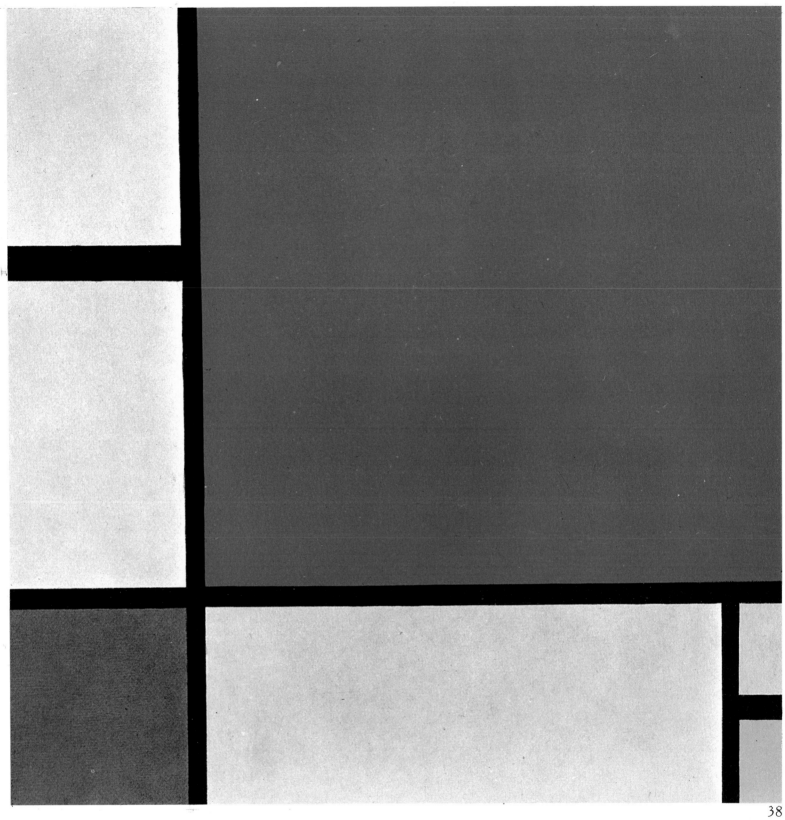

38

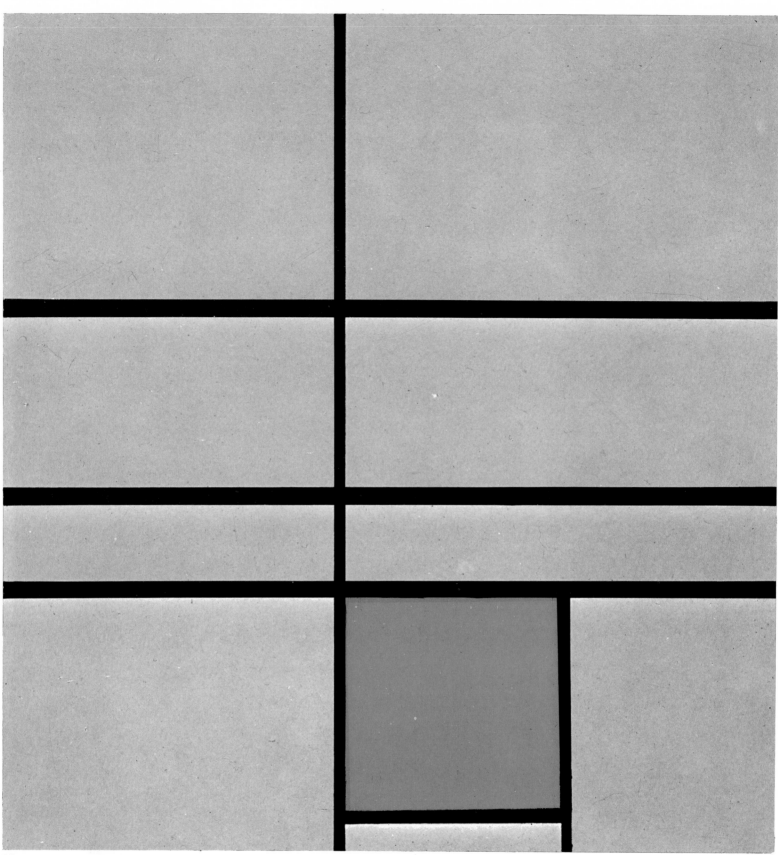

39

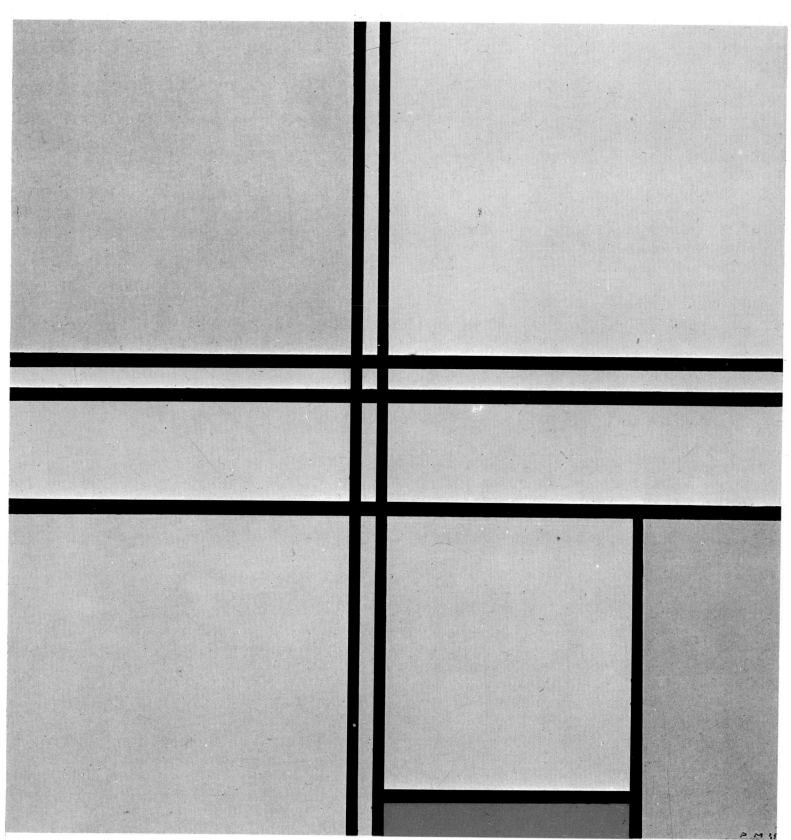

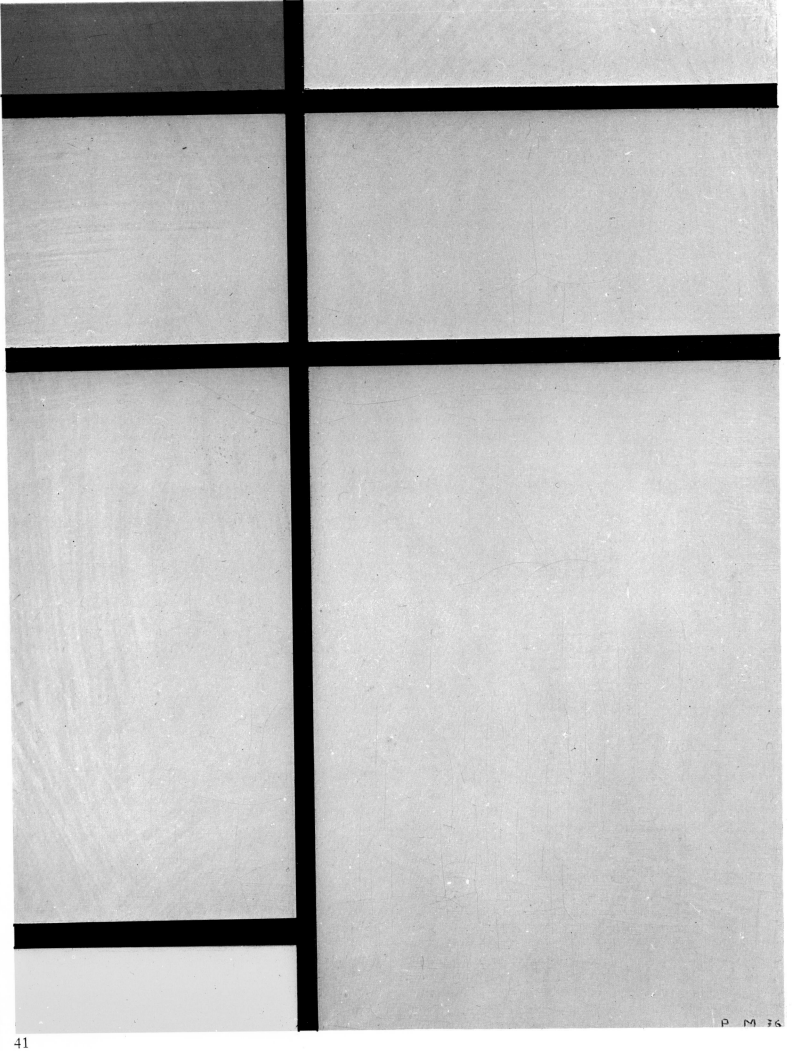

41

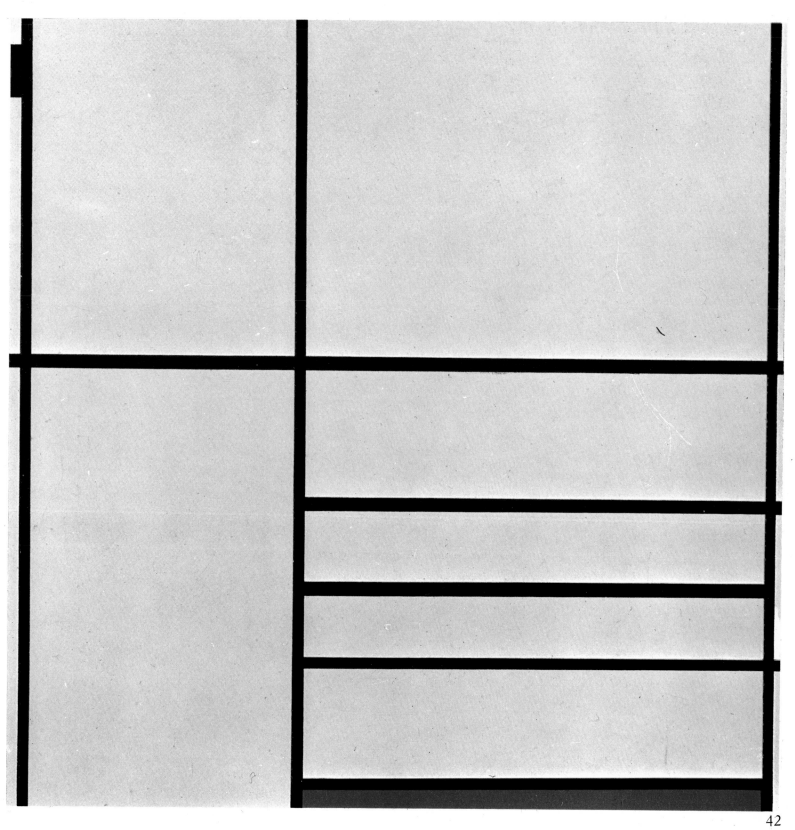

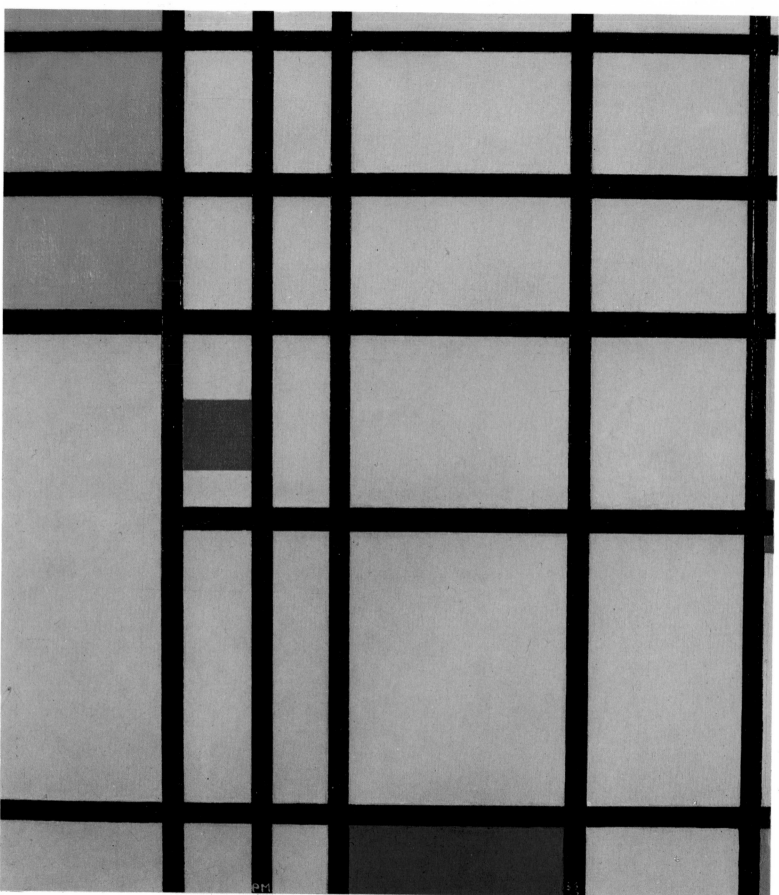

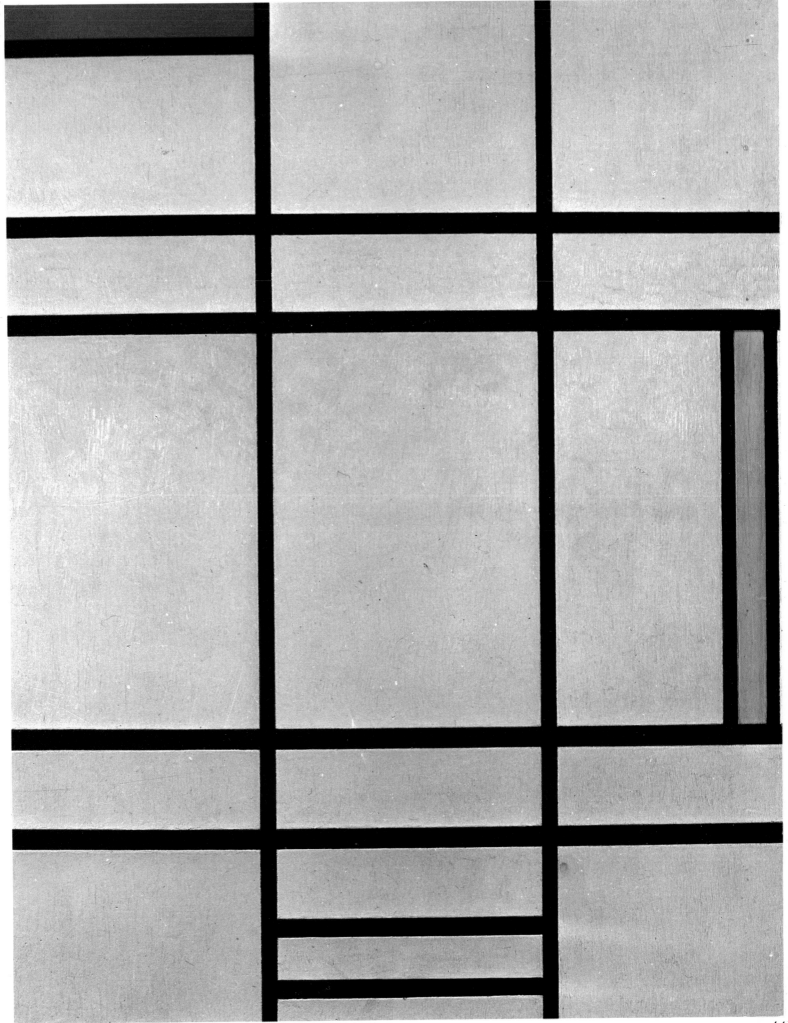

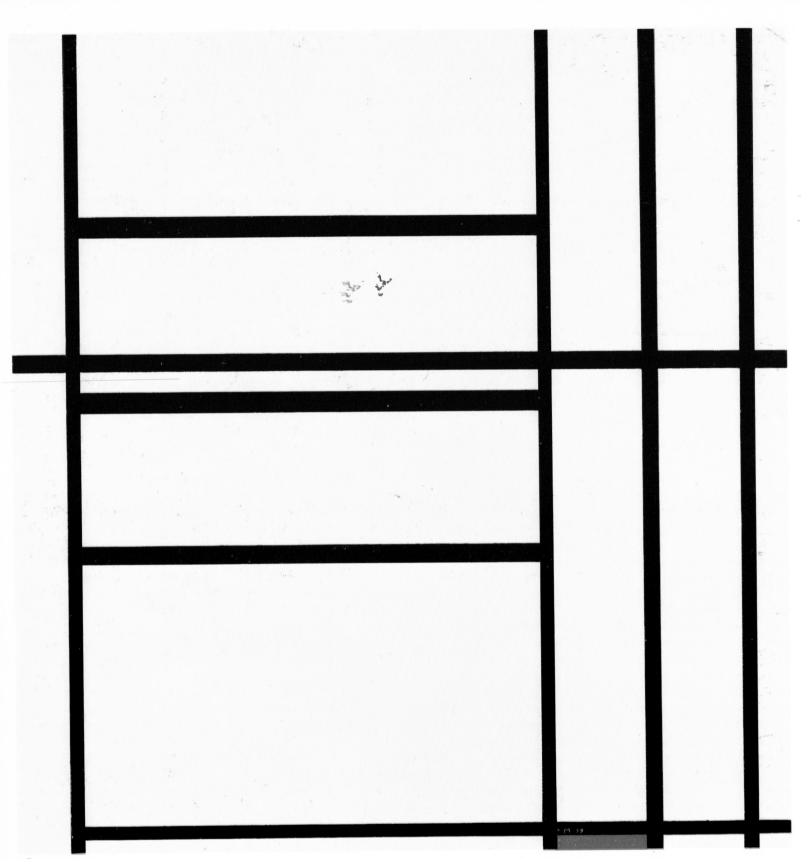

45

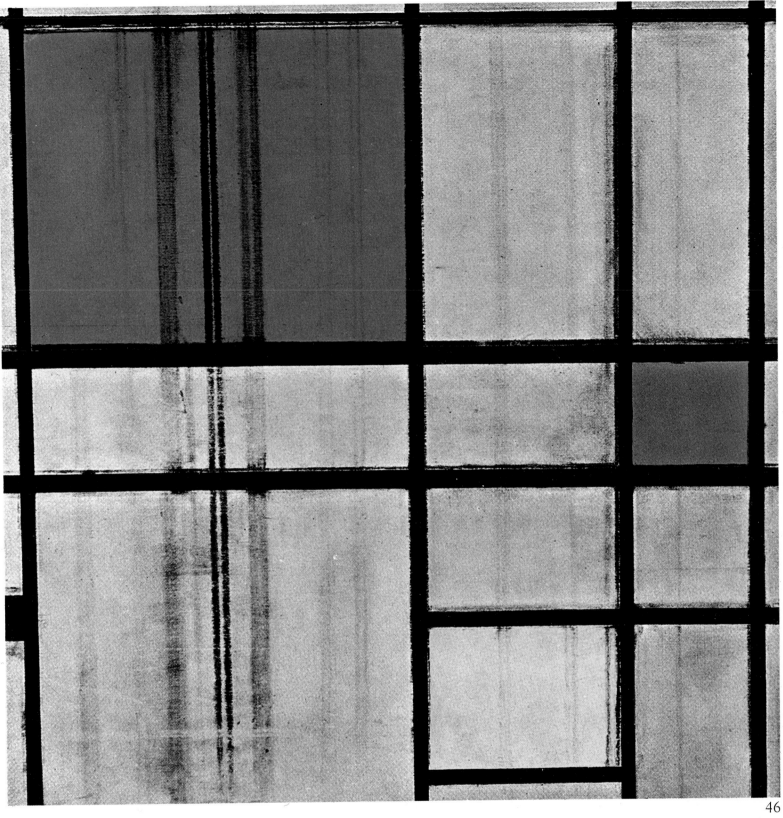

46

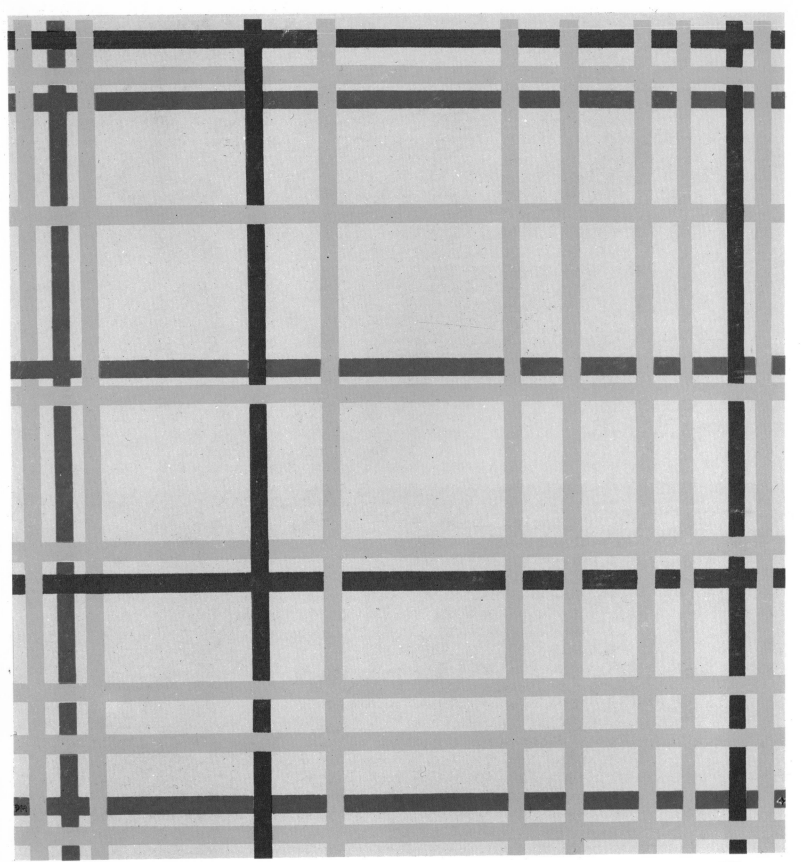

47

Description of colour plates

1 *Woods with Stream*
1880, charcoal with crayon on paper
Slijper collection, Blaricum

2 *Landscape*
undated, oil on canvas
Slijper collection, Blaricum

3 *Landscape near Amsterdam*
probably 1902, oil on canvas, $11\frac{1}{2} \times 18\frac{3}{4}$ in (29 × 48 cm)
Michel Seuphor collection, Paris

4 *Farm at Nistelrode*
c. 1904, watercolour, $17\frac{1}{4} \times 24\frac{1}{2}$ in (44 × 63 cm)
private collection, Holland

5 *Evening Landscape*
c. 1904, oil on canvas, $25 \times 36\frac{1}{2}$ in (64 × 93 cm)
Gemeentemuseum, The Hague

6 *Trees*
before 1908, oil on canvas, 52×37 in (132 × 94 cm)
Slijper collection, Blaricum

7 *Trees*
before 1908, oil on canvas, $18\frac{3}{4} \times 17$ in (48 × 43 cm)
Slijper collection, Blaricum

8 *Dune*
probably 1910, oil on canvas, $51 \times 73\frac{1}{4}$ in (130 × 186 cm)
Slijper collection, Blaricum

9 *Lighthouse at Westkapelle*
c. 1910, oil on cardboard, $15\frac{1}{4} \times 11\frac{1}{2}$ in (39 × 29 cm)
G. J. Nieuwenhuizen Segaar Gallery, The Hague

10 *Windmill in the Sun*
probably 1911, oil on canvas, $44\frac{1}{2} \times 34\frac{1}{4}$ in (114 × 87 cm)
Gemeentemuseum, The Hague, Slijper loan

11 *The Grey Tree*
1911, oil on canvas, $30\frac{1}{2} \times 42$ in (78 × 107 cm)
Gemeentemuseum, The Hague

12 *Flowering Apple Tree*
1912, oil on canvas, $30\frac{1}{2} \times 41\frac{1}{2}$ in (78 × 106 cm)
Gemeentemuseum, The Hague

13 *Flowering Trees*
1912, oil on canvas, $25\frac{1}{2} \times 29\frac{1}{2}$ in (65 × 75 cm)
G. J. Nieuwenhuizen Segaar Gallery, The Hague

14 *Still-life with Gingerpot I*
c. 1912, oil on canvas, $35\frac{1}{2} \times 29\frac{1}{2}$ in (91 × 75 cm)
Gemeentemuseum, The Hague

15 *Composition No. 11*
c. 1912, oil on canvas, $29 \times 21\frac{1}{2}$ in (74 × 55 cm)
Kröller-Müller Museum, Otterlo

16 *Composition, Tableau I*
1912–13, oil on canvas, $37\frac{3}{4} \times 25$ in (96 × 64 cm)
Kröller-Müller Museum, Otterlo

17 *Oval Composition (Trees)*
1913, oil on canvas, $36\frac{1}{2} \times 30\frac{3}{4}$ in (93 × 78 cm)
Stedelijk Museum, Amsterdam

18–19 *Composition in Blue, Grey and Pink*
1913, oil on canvas, $34\frac{1}{2} \times 45\frac{1}{4}$ in (88 × 115 cm)
Kröller-Müller Museum, Otterlo

20 *Oval Composition with Bright Colours*
1914, oil on canvas, 42 × 31 in (107 × 79 cm)
Museum of Modern Art, New York

21 *Oval Composition*
1914, oil on canvas, 44½ × 33 in (113 × 84 cm)
Gemeentemuseum, The Hague

22 *Composition in Grey and Yellow*
1914, oil on canvas, 24 × 30 in (61 × 76 cm)
Stedelijk Museum, Amsterdam

23 *Composition No. 7*
1914, oil on canvas, 47½ × 39¼ in (120 × 100 cm)
G. J. Nieuwenhuizen Segaar Gallery, The Hague

24 *Composition with Colour Planes on White Ground A*
1917, oil on canvas, 19¾ × 17¼ in (50 × 44 cm)
Kröller-Müller Museum, Otterlo

25 *Composition: Bright Colour Planes with Grey Lines*
1919, oil on canvas, 33 in (84 cm) diagonal
Kröller-Müller Museum, Otterlo

26 *Composition: Chequerboard, Dark Colours*
1919, oil on canvas, 33 × 40 in (84 × 102 cm)
Slijper collection, Blaricum

27 *Tableau I*
1921, oil on canvas, 37¾ × 23½ in (96 × 60 cm)
Müller-Widman collection, Basel

28 *Composition*
1921, oil on canvas, 19¼ × 17¾ in (49.5 × 45.5 cm)
Offentliche Kunstsammlungen, Basel

29 *Composition with Red, Yellow and Blue*
1921, oil on canvas, 15½ × 13¾ in (39.5 × 35 cm)
Gemeentemuseum, The Hague, Slijper loan

30 *Composition with Red, Yellow and Blue*
1921, oil on canvas, 18¾ × 18¾ in (48 × 48 cm)
Rothschild collection, New York

31 *Composition with Red, Yellow and Blue*
1921, oil on canvas, 31½ × 19¾ in (80 × 50 cm)
Gemeentemuseum, The Hague

32 *Tableau No. 2*
1921–25, oil on canvas, 29½ × 25½ in (75 × 65 cm)
Max Bill collection, Zurich

33 *Composition*
1922, oil on canvas,
Rothschild collection, New York

34 *Composition with Black and Blue*
1926, oil on canvas, 33½ × 33½ in (85 × 85 cm)
Philadelphia Museum of Art

35 *Composition with Red, Yellow and Blue*
1927, oil on canvas, 24 × 15¾ in (61 × 40 cm)
Stedelijk Museum, Amsterdam

36 *Tableau-Poème*
(text by Michel Seuphor) 1928, gouache, 25½ × 19¾ in (65 × 50 cm)
M. Seuphor collection, Paris

37 *Composition with Yellow and Blue*
1929, oil on canvas, 20½ × 20½ in (52 × 52 cm)
Boymans Museum, Rotterdam

38 *Composition with Red, Blue and Yellow*
1930, oil, 20 × 20 in (51 × 51 cm)
A. P. Bartos collection, New York

39 *Composition with Blue*
1935, oil on canvas, 28 × 27 in (71 × 69 cm)
H. Lewis Winston collection, Birmingham (Michigan)

40 *Composition*
1935, oil on canvas, 22 × 21¼ in (56 × 54 cm)
Chicago Art Institute

41 *Composition III: Blue and Yellow*
1936, oil on canvas, 17 × 13 in (43.5 × 33.5 cm)
Kunstmuseum, Basel

42 *Composition with Red and Black*
1936, oil on canvas, 40 × 41 in (102 × 104 cm)
Museum of Modern Art, New York

43 *Composition with Red, Yellow and Blue*
1936–43, oil on canvas, 23½ × 21½ in (60 × 55 cm)
Harry Holtzman collection, New York

44 *Composition with Yellow and Red*
1938–43, oil on canvas, 31 × 24¼ in (79.5 × 62 cm)
Harry Holtzman collection, New York

45 *Composition with Red*
1939, oil on canvas, 40 × 41 in (102 × 104 cm)
Peggy Guggenheim collection, Venice

46 *Composition with Red, Yellow and Blue*
(unfinished) 1939–44, oil on canvas, 28 × 28 in (71 × 71 cm)
Harry Holtzman collection, New York

47 *New York City*
1942, oil on canvas 47¼ × 56¾ in (120 × 144 cm)
Harry Holtzman collection, New York

Biographical outline

1872. Piet Cornelis Mondriaan born on the 7th March at Amersfoort, not far from Utrecht, the son of Pieter Cornelis and Johanna Christina Kok. On his father's side the family descended from a certain Christiaan Dirkzoon Monderyaan (or Munterjan, which means 'happy Jan') whose name is registered in The Hague in 1670.
1880. The Mondriaan family moved from Amersfoort to Winterswijk in the extreme east of the country, near the German border. His father wanted Piet to take up teaching (he was himself a school director). Frits Mondriaan, Piet's uncle, a professional landscape painter and pupil of Willem Maris, gave him his first painting lessons during two summer holidays at Winterswijk.
1889. Having decided to become a drawing teacher, Piet obtained a diploma to teach in elementary schools.
1892. Obtained another diploma which enabled him to teach in secondary schools. In November he left Winterswijk for Amsterdam, where he was a pupil of the Amsterdam Academy of Fine Arts for five years.
1901. Went to Spain with the painter Simon Maris, but he was disappointed with the Spanish people and their way of life.
1903. Went to Dutch Brabant with Albert van den Briel, whom he had known since 1899; decided to make a stay there.
1904. In January moved to Uden near Hertogenbosch (Bois-le-duc) in the Brabant.
1905. Returned to Amsterdam, where he remained until December 1911.
1907. In the summer he visited Oele, a village near Hengelee in the Province of Overyssel, with the painter Hulshoff.
1908. Spent the summer with the painter Cornelis Spoor at Domburg (where he returned for the next three summers), on the island of Walcheren in Zeeland. There he met and became friends with Jan Toorop. His mother died.
1909. January: exhibited with Cornelis Spoor and Jan Sluyters at the Municipal Museum in Amsterdam. The exhibition caused a considerable stir and antagonised the critics, with the exception of Conrad Kickert, who supported Mondrian.
1910. May: took part in the exhibition of the 'Luminist' painters at the Municipal Museum in Amsterdam. The lack of success of the previous year was repeated. Conrad Kickert founded the *Moderne Kunst Kring* (Modern Art Circle) and invited Mondrian, Toorop and Sluyters to become members of the board of directors.
1911. October: first exhibition of the *Moderne Kunst Kring* in honour of Cézanne, 28 of whose works are exhibited, together with works by Picasso, Braque, Derain, Dufy, Vlaminck, Redon, etc. Mondrian exhibits six paintings. December: Mondrian leaves for Paris, where he stays in Kickert's studio at 26, Rue du Départ, in Montparnasse.
1912. Influenced by Cubist painting. Changes his name from Mondriaan to Mondrian.
1913. Takes part in the IXth Salon des Indépendants, attracting the attention of Guillaume Apollinaire. First abstract works.
1914. Takes part in the XXXth Salon des Indépendants. In July returns to Holland because of his father's illness and is trapped there by the outbreak of the war. Stays at Arnhem with his father, at Amsterdam, Domburg and Laren. Begins the series known as *More and Less*.
1915. Meets Theo van Doesburg. His father dies at Arnhem.
1916. Meets Bart van der Leck at The Hague and visits him at Laren.
1917. With Theo van Doesburg, Bart van der Leck, Georges Vantongerloo, Vilmos Huszar, the architects J. J. P. Oud, Robert van t'Hoff, Jean Wils, and the poet Antoine Kok, founds the review *De Stijl*. The first number is published in October.
1918. The beginning of Neoplasticism; its theoretical principles are published in *De Stijl*.
1919. February: returns to Paris on the first train to leave Holland for France.
1920. Publishes *Le Néo-Plasticisme*.

1923. November: *De Stijl* exhibition at Léonce Rosenberg's *L'Effort Moderne* gallery.
1925. German translation of *Le Néo-Plasticisme* published by the Bauhaus at Weimar under the title of *Neue Gestaltung*.
1926. One of his paintings, bought by Katherine Dreier, is exhibited for the first time in America, at the Brooklyn Museum.
1929. Joins the *Cercle et Carré* group founded by Michel Seuphor and Torres-Garcia in Paris.
1930. Exhibition of the *Cercle et Carré* group in Paris.
1931. The *Cercle et Carré* group breaks up because of Seuphor's serious illness and Mondrian joins the 'Abstraction-Création' group of August Herbin and Georges Vantongerloo.
1934. Meets Ben Nicholson and Harry Holtzman, who was to become the most important collector of his works.
1936. Leaves his old studio in the Rue du Départ and moves to the Boulevard Raspail.
1938. 21st September: convinced that Paris will be destroyed from the air by the Germans, he leaves for London intending to go on to America; Ben Nicholson and Naum Gabo find him a studio in Hampstead, however, and he settles down in London.
1940. The bombing of London drives him on to America; he embarks at the end of September and arrives in America on the 3rd October.
1942. His first one-man show held at Dudensing's gallery in New York in January–February.
1943. Second one-man show in New York, at the same gallery, in March–April.
1944. Dies of pneumonia on 1st February at the Murray Hill Hospital in New York.

32 Piet Mondrian in 1937

Chronological catalogue of works

1880 *Woods with Stream* Blaricum, Slijper collection

1890 *Cows on the Bank of a River* Blaricum, Slijper collection

1892 *Barge on the Amstel* Blaricum, Slijper collection

1893 *Still-life with Fish* Amsterdam, Ranch collection

1895 *Still-life with Apples* The Hague, Municipal Museum; *Seascape* The Hague, Nieuwenhuizen Segaar Gallery; *Portrait of an Old Man* Paris, Michel Seuphor collection

1898 *Hayrick near Pond* de Meern, van den Briel collection

1899 *Puppy* Hilversum, J. J. Lambeek

Before 1900 *Still-life* Groningen Museum; *Girl Writing* The Hague, Gemeentemuseum; *Moat* Utrecht, Douwe van der Eweep

1900 *Self-portrait* New York, Sidney Janis Gallery; *Portrait of a Woman* Blaricum, Slijper collection; *Farm in the Evening* Blaricum, Slijper collection; *The Boulevard of Amsterdam* Blaricum, Slijper collection; *Mill on River* Blaricum, Slijper collection; *Boat on a Sand-bank* Blaricum, Slijper collection; *Country Church* Blaricum, Slijper collection; *Factory* de Meern, van den Briel collection; *On the Gein: Mill in Moonlight* The Hague, Gemeentemuseum; *Flowers* The Hague, Nieuwenhuizen Segaar Gallery; *Shipyard* The Hague, Nieuwenhuizen Segaar Gallery; *Mill* The Hague, van Audel collection; *Tree* Paris, collection of the Economic Attaché to the Embassy of the Low Countries

1900–5 *Evening Landscape* Blaricum, Slijper collection; *Isolated Tree* Blaricum, Slijper collection; *Trees by Water* Blaricum, Slijper collection; *Woods at Sunset* Blaricum, Slijper collection; *Landscape with Bridge* Blaricum, Slijper collection; *Farm near Blaricum* Blaricum, Slijper collection; *Farm and Farmer's Wife* Blaricum, Slijper collection; *Landscape* Amsterdam, Stedelijk Museum; *Cows Grazing* Amersfoort, Kramer collection; *Mill* Amersfoort, Kramer collection; *Watergraafsmeer* The Hague, K. Legat collection; *Landscape with Mill* London, van Dam collection

1902 *The River Amstel in the Evening* Blaricum, Slijper collection; *The River Gein: Trees at Moonrise* Blaricum, Slijper collection; *Farm and Trees in Moonlight* Blaricum, Slijper collection; *Cows* Blaricum, Slijper collection; *Cows Grazing* Blaricum, Slijper collection; *Mill by the Water* Blaricum, Slijper collection; *Landscape* Blaricum, Slijper collection; *Portrait of a Woman* Blaricum, Slijper collection; *The River Gein: Trees at Moonrise* de Meern, van den Briel collection; *Landscape near Amsterdam* Paris, Michel Seuphor collection; *Trees on the River Gein* Heemstede, T. Bruin-Reitsma collection

1902–3 *Willows* Blaricum, Slijper collection; *Landscape with Cattle* Blaricum, Slijper collection; *Autumn Landscape* Blaricum, Slijper collection; *Landscape* Blaricum, Slijper collection

1903 *The River Gein: Willows* Blaricum, Slijper collection; *Two Cows in the Stable* Blaricum, Slijper collection; *The River Gein: Willows* Blaricum, Slijper collection; *The River Gein: Willows* The Hague, Nieuwenhuizen Segaar Gallery; *The River Gein: Willows* Heemstede, T. Bruin-Reitsma collection; *Landscape with Pond and Trees* Paris, private collection

1903–4 *White Bull-calf,* de Meern, van den Briel collection; *Study for Passionflower* de Meern, van den Briel collection; *Passionflower* de Meern, van den Briel collection

1903–5 *Woods* Blaricum, Slijper collection; *Mill by the Lake* Blaricum, Slijper collection; *Woods* Delden, van Heck collection

1904 *Landscape* Blaricum, Slijper collection; *Landscape in Brabant* Blaricum, Slijper collection; *Woods* Blaricum, Slijper collection; *Landscape* Blaricum, Slijper collection; *Huts by Water* Blaricum, Slijper collection; *St Bernard Dog* Blaricum, Slijper collection; *Church* Blaricum, Slijper collection; *Farm in Brabant* Blaricum, Slijper collection; *Sunflower* Blaricum, Slijper collection; *Nude* New York, Holtzman collection; *Evening Landscape* The Hague, Gemeentemuseum; *Willows* Paris, Kickert collection; *Night Landscape* Kelowna (British Columbia), Ootmar collection; *Farm at Nistelrode* Holland, private collection

1904–5 *Farmer's Wife in Front of a Farmhouse* Blaricum, Slijper collection; *Farmer's Wife with Child in Front of a Farmhouse* Blaricum, Slijper collection

1905 *Portrait of a Woman* Blaricum, Slijper collection; *Landscape with Farm* Blaricum, Slijper collection; *Sheepfold in Brabant* Blaricum, Slijper collection; *The River Amstel* Blaricum, Slijper collection; *Trees by Water* Blaricum, Slijper collection; *Impression at Evening on the River Amstel* Blaricum, Slijper collection; *Landscape* Blaricum, Slijper collection; *Landscape* Blaricum, Slijper collection; *Landscape* Blaricum, Slijper collection; *Rolling Country* Blaricum, Slijper collection; *Landscape with Farm* Blaricum, Slijper collection; *Landscape* Blaricum, Slijper collection; *Forest* Blaricum, Slijper collection; *Willows* Blaricum, Slijper collection; *Willows by Water* Blaricum, Slijper collection; *Willows* Blaricum, Slijper collection; *Willows* Blaricum, Slijper collection; *Willows by Water* Blaricum, Slijper collection; *Cattle* Blaricum, Slijper collection; *Cattle by Water* Blaricum, Slijper collection; *Landscape with Cattle* Blaricum, Slijper collection; *Landscape with Cattle* Blaricum, Slijper collection; *Landscape with Cattle* Blaricum, Slijper collection; *Farm* Blaricum, Slijper collection; *Farm* Blaricum, Slijper collection; *Farm with Trees by Water* Blaricum, Slijper collection; *Farm by Water* Blaricum, Slijper collection; *Farm at Blaricum* Blaricum, Slijper collection; *Farm* Blaricum, Slijper collection; *Farm* Blaricum, Slijper collection; *Farmhouse* Blaricum, Slijper collection; *Farmhouse by the River* Blaricum, Slijper collection; *Farmhouse* Blaricum, Slijper collection; *House and Trees by Water* Blaricum, Slijper collection; *Trees by Water* Blaricum, Slijper collection; *Garden* Blaricum, Slijper collection; *Farmhouse with Haycock* Blaricum, Slijper collection; *Stable* Blaricum, Slijper collection; *Barn* Blaricum, Slijper collection; *Windmill* Blaricum, Slijper collection; *Mill by the Water* Blaricum, Slijper collection; *Mill* Blaricum, Slijper collection; *Kitchen Garden* Blaricum, Slijper collection; *Dredge in the Evening* Blaricum, Slijper collection; *Landscape with Haycocks* Blaricum, Slijper collection; *Landscape with Farm* Amsterdam, Stedelijk Museum; *Rhododendron* Blaricum, Slijper collection; *Iris* Blaricum, Slijper collection; *Iris in a Vase* Blaricum, Slijper collection; *Amaryllis* Blaricum, Slijper collection; *Amaryllis* Blaricum, Slijper collection; *Banks of the River Amstel* Paris, private collection; *Landscape with Factory* Paris, private collection

1905–6 *River Scene* Crommelin collection

1906 *Landscape* Blaricum, Slijper collection; *Landscape* Blaricum, Slijper collection; *Landscape* Blaricum, Slijper collection; *Evening Landscape* Blaricum, Slijper collection; *Landscape* Blaricum, Slijper collection; *Evening Landscape with Haycock* Blaricum, Slijper collection; *Landscape with Tree* Blaricum, Slijper collection; *Landscape with Solitary Tree* Blaricum, Slijper collection; *Landscape with Mill* Blaricum, Slijper collection; *Dutch Village* Blaricum, Slijper collection; *Trees by Water* Blaricum, Slijper collection; *Trees by Water* Blaricum, Slijper collection; *Tree* Blaricum, Slijper collection; *Trees* Blaricum, Slijper collection; *Kitchen-garden with Haycocks* Blaricum, Slijper collection; *Dredge* Blaricum, Slijper collection; *Meadows* Blaricum, Slijper collection; *Cattle in a Meadow* Blaricum, Slijper collection; *Boat* Blaricum, Slijper collection; *Flowers* Blaricum, Slijper collection; *Flowers* Blaricum, Slijper collection; *Flowers* Blaricum, Slijper collection; *Chrysanthemum* Blaricum, Slijper collection; *Chrysanthemum* Blaricum, Slijper collection; *Chrysanthemum* Blaricum, Slijper collection; *Chrysanthemum* Blaricum, Slijper collection; *Anemones* Blaricum, Slijper collection; *Chrysanthemum* New York, Holtzman collection; *Chrysanthemum* New York, Holtzman collection; *Chrysanthemum* New York, Holtzman collection; *Chrysanthemum* New York, Holtzman collection

1906–7 *Landscape* Blaricum, Slijper collection

1906–8 *Chrysanthemum* Blaricum, Slijper collection; *Isolated Farm* Blaricum, Slijper collection; *Chrysanthemum* Blaricum, Slijper collection

1907 *The River Amstel in the Evening* Blaricum, Slijper collection; *Landscape with Trees* Blaricum, Slijper collection; *Evening Landscape* Blaricum, Slijper collection; *Trees* Blaricum, Slijper collection; *Isolated Farm* Blaricum, Slijper collection; *Sheepfold in the Evening* Blaricum, Slijper collection; *By the River* Blaricum, N. Hart collection; *Winter Landscape* The Hague, Gemeentemuseum; *Landscape* de Meern, van den Briel collection; *Chrysanthemums* Blaricum, Slijper collection; *Chrysanthemum* Blaricum, Slijper collection; *Dying Chrysanthemum* Blaricum, Slijper collection; *Amaryllis* Blaricum, Slijper collection; *Chrysanthemums* Blaricum, Slijper collection; *Dying Chrysanthemum* Blaricum, Slijper collection; *Two Marigolds* New York, Holtzman collection; *Two Marigolds* New York, Holtzman collection; *Red Dahlia* New York, C. von Wiegand collection; *Amaryllis* U.S.A., private collection; *Trees by Water, with Yellow Quarter Moon* Paris, private collection: *Landscape with large Tree* Paris, Esser collection; *Trees by a Pond* Paris, Esser collection; *Trees Along a Bank* Paris, Esser collection; *Trees on the Bank of a River* Paris, Esser collection

1907–8 *Dying Chrysanthemum* Blaricum, Slijper collection

1907–9 *The Red Cloud* The Hague, Gemeentemuseum; *Flower* Blaricum, Slijper collection; *Dying Chrysanthemum* Blaricum, Slijper collection; *Flower* Blaricum, Slijper collection; *Flower* Blaricum, Slijper collection

Before 1908 *Landscape* Blaricum, Slijper collection; *Landscape with Trees* Blaricum, Slijper collection; *Trees on the River Gein* Blaricum, Slijper collection; *Trees* Blaricum, Slijper collection; *Landscape near Oele* Blaricum, Slijper collection; *Farm near Duivendrecht* Blaricum, Slijper collection; *Farm near Duivendrecht* Blaricum, Slijper collection; *Farm with Poultry Yard* Blaricum, Slijper collection; *Trees* Otterlo, Kröller-Müller Museum; *Landscape with Trees* Otterlo, Kröller-Müller Museum; *Landscape in Moonlight* The Hague, Gemeentemuseum; *Landscape* Amsterdam, Knap collection; *Landscape* Sweden, private collection; *Farm near Duivendrecht* Laren, E. Diamant collection; *Farm near Duivendrecht* New York, Sidney Janis Gallery; *Farm near Duivendrecht* New York, Sidney Janis Gallery;

Farm near Duivendrecht Haarlem, Frans Hals Museum; *Farm near Duivendrecht* The Hague, J. P. Back collection; *Farm near Duivendrecht* A. W. Rabbie Vuyk collection; *Landscape with Trees* Paris, private collection; *Large Landscape with Trees, Farm and Cattle* Paris, private collection; *Landscape with Trees* Paris, private collection; *Large Tree with Railing* Paris, private collection; *Landscape with Bare Trees* Paris, private collection; *Tree in a Meadow* Paris, private collection; *Windmill* Paris, Esser collection; *Portrait of a Woman* Paris, Esser collection; *Farm near Duivendrecht* Paris, Esser collection; *Four Drawings of the Farm at Duivendrecht* Paris, Esser collection

1908 *Evening* Blaricum, Slijper collection; *Bridge with House and Farmer* Blaricum, Slijper collection; *Fir-tree* Blaricum, Slijper collection; *Zeeland Farmer* Blaricum, Slijper collection; *Child Praying* Blaricum, Slijper collection; *Self-portrait* Blaricum, Slijper collection; *Portrait of a Man* Blaricum, Slijper collection; *Two Figures* Blaricum, Slijper collection; *Young Girl* Blaricum, Slijper collection; *Hayricks* New York, Sidney Janis Gallery; *The Sea* Oosterbeek, M. Donk-Kaars Sypersteyn; *Hayricks* New York, Museum of Modern Art; *Church in Zeeland* New York, Alex Lewyt collection; *Zuyderzee* Marseilles, private collection; *Dunes* New York, C. von Wiegand collection; *Rose* Blaricum, Slijper collection; *Chrysanthemum* Blaricum, Slijper collection; *Chrysanthemum* Blaricum, Slijper collection; *Chrysanthemums* Blaricum, Slijper collection; *Chrysanthemum* Blaricum, Slijper collection; *Chrysanthemum* Blaricum, Slijper collection; *Chrysanthemum* New York, Holtzman collection; *Chrysanthemum* New York, Holtzman collection; *Chrysanthemum* New York, Holtzman collection; *Chrysanthemum* New York, Holtzman collection; *Chrysanthemum* New York, Holtzman collection; *Chrysanthemum* New York, Holtzman collection; *Chrysanthemum* The Hague, Gemeentemuseum; *Chrysanthemum* New York, Sidney Janis Gallery; *Tug at Moorings* Paris, private collection; *Chrysanthemum* Paris, Esser collection; *Bridge with Light* Paris, Esser collection

1908–9 *Chrysanthemum* D. Ogden Stewart collection

1908–10 *Beach near Domburg* Blaricum, Slijper collection; *Chrysanthemums* Blaricum, Slijper collection

1909 *Mill near Blaricum in Moonlight* Blaricum, Slijper collection; *Dune* Blaricum, Slijper collection; *Beach at Domburg* Blaricum, Slijper collection; *Lighthouse at Westkapelle* Blaricum, Slijper collection; *Church Tower at Domburg* Blaricum, Slijper collection; *Church Tower at Domburg* Blaricum, Slijper collection; *Dunes and Sea* New York, Holtzman collection; *Dunes* New York, Holtzman collection; *Dunes and Sea* New York, Holtzman collection; *Mill at Domburg* Holland, private collection; *Hayricks* Kelowna, Ootmar collection; *Sea at Sunset* de Meern, van den Briel collection; *Three Chrysanthemums* Paris, private collection; *Village Street with Cock* Paris, private collection; *Village Street with Wheel-barrow* Paris, private collection; *Tree and Boat by the Water* Paris, Esser collection

1909–10 *Dunes and Sea* Blaricum, Slijper collection; *Tree* Blaricum, Slijper collection; *Sea* Blaricum, Slijper collection; *The Red Tree* The Hague, Gemeentemuseum; *The Blue Tree* De Bilt, van Dijk collection; *Tree* Kelowna, Otmar collection; *Tree* Hilversum, Heybroek collection

1910 *Dune* Blaricum, Slijper collection; *Woods* Blaricum, Slijper collection; *Dune* Blaricum, Slijper collection; *Dune* Blaricum, Slijper collection; *The Lighthouse at Westkapelle* Blaricum, Slijper collection; *Dune* Blaricum, Slijper collection; *The Church at Domburg* Blaricum, Slijper collection; *The Church Tower at Domburg* Blaricum, Slijper collection; *The Lighthouse at Westkapelle* Blaricum, Slijper collection; *The Lighthouse at Westkapelle* Blaricum, Slijper collection; *The Lighthouse at Westkapelle* Blaricum, Slijper collection; *Mill at Domburg* Blaricum, Slijper collection; *Landscape Study* Blaricum, Slijper collection; *The Lighthouse at Westkapelle* Blaricum, Slijper collection; *Self-portrait* Blaricum, Slijper collection; *Self-portrait* (on the back: *Eucalyptus*), Blaricum, Slijper collection; *Portrait of a Woman* Blaricum, Slijper collection; *Portrait of a Woman* Blaricum, Slijper collection; *The Beach near Domburg* Osterbeek, Donk collection; *Dune* The Hague, Nieuwenhuizen Segaar Gallery; *Dune* Heemstede, Bruin Reitsma collection; *Tree* New York, Holtzman collection; *Trees* New York, Holtzman collection; *Calla Lily* Blaricum, Slijper collection; *Sunflower* Blaricum, Slijper collection; *Calla Lily* Blaricum, Slijper collection; *Rose* New York, Holtzman collection; *Rose* Paris, C. Zervos collection; *Chrysanthemum* New York, private collection; *Rhododendron* Heemstede, Bruin-Reitsma collection; *Chrysanthemum* Amsterdam, Stedelijk Museum; *Church Tower in Zontelande* Hilversum, Heybroek collection; *Farmhouse* The Hague, Gemeentemuseum; *Calla Lilies* Blaricum, Slijper collection; *Eucalyptus* New York, Sidney Janis Gallery; *Landscape with Telegraph Poles* Paris, Esser collection; *Chrysanthemum* Paris, Esser collection

1910–11 *Tree* Domburg, Elout-Drabbe collection

1911 *Self-portrait* Blaricum, Slijper collection; *Trees* Blaricum, Slijper collection; *Tree* Blaricum, Slijper collection; *Trees* Blaricum, Slijper collection; *Evolution Triptych* Blaricum, Slijper collection; *The Grey Tree* Blaricum, Slijper collection; *Tree* New York, Holtzman collection; *Trees* New York, Holtzman collection; *Tree* New York, Holtzman collection; *Trees* New York, Holtzman collection; *Tree* New York, Holtzman collection; *Self-portrait* New York, Holtzman collection; *Tree* New York, Sidney Janis Gallery; *Windmill in the Sun* Blaricum, Slijper collection; *Pathetic Composition with Angular Figures* Paris, private collection

1911–12 *Composition in Grey* Blaricum, Slijper collection

1912 *Portrait of a Woman* Blaricum, Slijper collection; *Female Figure* Blaricum, Slijper collection; *Nude* Blaricum, Slijper collection; *Landscape with Trees* Blaricum, Slijper collection; *Landscape* Blaricum, Slijper collection; *Composition No. 3* Blaricum, Slijper collection; *Composition with Trees* Blaricum, Slijper collection; *Composition in Grey-Blue* Blaricum, Slijper collection; *Composition with Trees* Blaricum, Slijper collection; *Still-life with Gingerpot I* Blaricum, Slijper collection; *Still-life with Gingerpot II* Blaricum, Slijper collection; *Self-portrait* Blaricum, Slijper collection; *Oval Composition* Blaricum, Slijper collection; *Roofs* New York; Holtzman collection; *Façade* New York, Holtzman collection; *Scaffolding* New York, Holtzman collection; *Wall of a House in Paris* New York, Holtzman collection; *Façade* New York, Holtzman collection; *Roofs* New York, Holtzman collection; *Composition* New York, Holtzman collection; *Nude* New York, Holtzman collection; *Composition No. 11* Otterlo, Kröller-Müller Museum; *Apple-tree* The Hague, Nieuwenhuizen Segaar Gallery; *Flowering Trees* The Hague, Nieuwenhuizen Segaar Gallery; *Tree* New York, Sidney Janis Gallery; *The Sea* New York, Sidney Janis Gallery; *Tree* New York, C. von Wiegand collection; *Composition No. 1* Rotterdam, J. Huding L. Izn collection; *Scaffolding* Venice, P. Guggenheim collection; *Eucalyptus* Kitchawan (U.S.A.), A. Rothschild collection

1912–13 *Oval Composition (Tree)* New York, Sidney Janis Gallery

1913 *Tableau I* Otterlo, Kröller-Müller Museum; *Composition in Blue, Grey and Pink* Otterlo, Kröller-Müller Museum; *Composition No. 2* Otterlo, Kröller-Müller Museum; *Oval Composition* New York, Holtzman collection; *Façade in Brown and Grey* New York, Museum of Modern Art; *Oval Composition with Bright Colours* New York; *Oval Composition (Trees)* The Hague, Bremmer collection; *Composition No. 9 (Scaffolding)* New York, J. L. Senior, Jr., collection; *Composition No. 7* New York, Guggenheim Museum; *Façade in Brown and Grey* New York, E. Kaufmann Jr. collection; *Composition No. 14 in Grey and Brown* Eindhoven, Stedelijk, von Abbe Museum

1913–14 *Seascape* New York, Holtzman collection

1914 *The Church at Domburg* Blaricum, Slijper collection; *Pier and Ocean* Blaricum, Slijper collection; *The Church at Domburg* Blaricum, Slijper collection; *Composition No. 6* Blaricum, Slijper collection; *Oval Composition* Blaricum, Slijper collection; *The Sea* New York, Holtzman collection; *Pier and Ocean* New York, Holtzman collection; *The Sea* New York, Holtzman collection; *Church Façade* New York, Holtzman collection; *Pier and Ocean* New York, Holtzman collection; *Church Façade* New York, Holtzman collection; *Pier and Ocean* New York, Holtzman collection; *Church Façade* New York, Holtzman collection; *Seascape* New York, Sidney Janis Gallery; *Façade No. 5* New York, Sidney Janis Gallery; *Composition with Colour Planes* New York, Sidney Janis Gallery; *Scaffolding* New York, C. von Wiegand collection; *The Sea* Venice, P. Guggenheim collection; *The Sea* Montreaux, Th. Bally collection; *Pier and Ocean* Meriden, Burton Tremaine collection; *Pier and Ocean* New York, Museum of Modern Art; *Composition No. 8* New York, Museum of Modern Art; *Church Façade* New York, L. Glarner collection; *Composition in Grey and Yellow* Amsterdam, Stedelijk Museum; *Oval Composition* Amsterdam, Stedelijk Museum; *Composition No. 7* The Hague, Nieuwenhuizen Segaar Gallery

1914–15 *Oval Composition* New York, Museum of Modern Art

1915 *Pier and Ocean* Otterlo, Kröller-Müller Museum

1916 *Mill at Blaricum* Blaricum, Slijper collection; *Mill at Blaricum* Blaricum, Slijper collection; *Mill at Blaricum* Blaricum, Slijper collection; *Calla Lily* Blaricum, Slijper collection; *Calla Lily* Blaricum, Slijper collection; *Mill* Amsterdam, Stedelijk Museum; *Composition* New York, Holtzman collection; *Composition* New York, Guggenheim Museum

1917 *Composition with Lines* Otterlo, Kröller-Müller Museum; *Composition with Colour Planes B* Otterlo, Kröller-Müller Museum; *Composition with Colour Planes on a White Ground* Otterlo, Kröller-Müller Museum; *Composition with Colour Planes on a White Ground* New York, B. H. Friedman collection; *Composition in Blue B* Otterlo, Kröller-Müller Museum; *Composition No. 3 with Colour Planes* The Hague, Gemeentemuseum; *Composition with Colour Planes* Rotterdam, Boymans Museum; *Composition No. 5 with Colour Planes* The Hague, J. D. Waller collection

1918 *Sketch for Self-portrait* Blaricum, Slijper collection; *Self-portrait* Blaricum, Slijper collection; *Composition in Grey and Brown* collection unknown; *Lozenge Composition with Grey Lines* Holland, private collection; *Chrysanthemum in a Glass* Amsterdam, van Loon collection

1919 *Chequerboard Composition with Bright Colours* Blaricum, Slijper collection; *Chequerboard Composition with Dark colours* Blaricum, Slijper collection; *Composition: Bright Colours with Grey Lines* Otterlo, Kröller-Müller Museum; *Lozenge Composition* Otterlo, Kröller-Müller Museum; *Composition in Grey and Black* New York, Sidney Janis Gallery; *Composition* New York, Sidney Janis Gallery; *Composition in Grey* New York, Holtzman collection; *Composition: Colour Planes with Grey Lines* Zurich, Max Bill collection; *Composition with Bright Colours* Basel, M. Hagenbach collection; *Lozenge Composition with Grey Lines* Philadelphia Museum of Art

1920 *Composition with Red, Blue, Black and Yellow-green* New York, Museum of

94

Modern Art; *Composition with Red, Blue and Green* Wassenaar, J. J. P. Oud collection; *Composition* Zurich, Max Welti collection; *Composition with Red, Yellow and Blue* Amsterdam, van der Muijzenberg Willemse collection

1921 *Composition* Blaricum, Slijper collection; *Composition with Red, Yellow and Blue* Blaricum, Slijper collection; *Composition with Red, Yellow and Blue* The Hague, Gemeentemuseum; *Composition* The Hague, Legat collection; *Composition* Basel Museum, *Composition* New York, Bartos collection; *Composition* New York, Bartos collection; *Tableau I* Basel, Müller Widmann collection; *Composition with Large Blue Plane and Red and Yellow Rectangles* New York, Sidney Janis Gallery; *Composition with Grey, Blue, Yellow and Red* collection unknown; *Composition with Red, Yellow and Blue* New York, Rothschild collection; *Composition in a Square* New York, J. L. Senior jr. collection; *Composition with Grey Ground* collection unknown

1921–5 *Tableau No. I* Zurich, Moser-Schindler collection; *Tableau No. II* Zurich, Max Bill collection

1922 *Composition* Blaricum, Slijper collection; *Composition with Red, Blue and Yellow* Amsterdam, Stedelijk Museum; *Composition in a Square* New York, Sidney Janis Gallery; *Composition* New York, Holtzman collection; *Composition with Blue, Red and Yellow (Tableau XI)* Krefeld, Kaiser Wilhelm Museum; *Composition* New York, Rothschild collection; *Composition* Rosen collection; *Composition with Red, Yellow and Blue* Wassenaar, J. J. P. Oud collection; *Composition with Red, Yellow and Blue* Reenwijk, Til Brugman collection

1923 *Composition* Basel, Beyeler collection

1925 *Composition* New York, Museum of Modern Art; *Composition in a Square* Utrecht, Cabos collection; *Composition in a Square with Red, Yellow and Blue* New York, Holtzman collection; *Composition No. 1 with Blue and Yellow* New York, Sidney Janis Gallery; *Tableau II: Black, Grey and White* Basel, Beyeler collection; *Composition with Yellow, Red and Blue (Tableau III)* Krefeld, Kaiser Wilhelm Museum

1926 *Composition with Yellow, Red and Blue (Tableau X)* Krefeld, Kaiser Wilhelm Museum; *Composition with Red and Blue* Krefeld, Kaiser Wilhelm Museum; *Composition in Black and White* New York, Museum of Modern Art; *Composition with Black and Blue* Philadelphia Museum of Art; *Composition* New York, Holtzman collection; *Composition in a Square* New York, Holtzman collection; *Composition with Red, Yellow and Blue* New York, Sidney Janis Gallery; *Stage-sets I, II, and III: for L'Ephemère est éternel* (lost)

1927 *Composition with Red, Yellow and Blue* Amsterdam, Stedelijk Museum; *Composition* New York, Holtzman collection; *Composition* New York, Holtzman collection; *Composition* New York, Sidney Janis Gallery; *Composition with Black and Red* New York, Sidney Janis Gallery; *Composition with Red, Yellow and Blue* New York, Sidney Janis Gallery; *Composition with Red, Yellow and Blue* Arnhem, de Jonge van Ellemeet collection; *Composition I with Black, Yellow and Blue* Zurich, Giedion Welcker collection; *Composition III with Red, Yellow and Blue* Rotterdam, Elenbaas collection; *Composition* Zurich, Werner Moser-Schindler collection; *Fox-trot A* New Haven, Yale University; *Composition with Red, Yellow and Blue* Wassenaar, J. J. P. Oud collection; *Composition* Basel, Beyeler collection

1928 *Composition with Red, Yellow and Blue* New York, Sidney Janis Gallery; *Composition with Red, Yellow and Blue* Amsterdam, Martin Stam collection; *Large Composition with Red, Blue and Yellow* New York, L. Senior jr. collection; *Tableau Poème* (text by Michel Seuphor), Paris, M. Seuphor collection

1929 *Composition with Yellow and Blue* Rotterdam, Boymans Museum; *Composition in a Square* New Haven, Yale University; *Fox-trot B* New Haven, Yale University; *Composition II with Red, Blue and Yellow* Belgrade, National Museum; *Composition with Red, Yellow and Blue* Amsterdam, Karsten collection; *Composition III* Montreux, Th. Bally collection; *Composition* Basel, M. Habenbach collection; *Composition with Yellow and Blue* Amsterdam, Arthur Lehning collection

1930 *Composition with Blue, Red and Yellow* New York, Sidney Janis Gallery; *Composition I* Zurich, E. Friedrich-Zetzler collection; *Composition II with Yellow and Blue* Zurich, Giedion-Welcker collection; *Composition with Red, Yellow and Blue* Zurich, A. Roth collection; *Composition with Yellow* Basel, Jan Tschichold collection; *Composition* New York, Holtzman collection; *Composition with Red, Blue and Yellow* New York, A. P. Bartos collection; *Composition I with Black Lines* New York, John L. Senior jr. collection; *Composition II with Black Lines* Eindhoven, Stedelijk von Abbe Museum; *Composition IA* U.S.A., Hilla Rebay collection

1931 *Composition with Two Lines* Amsterdam, Stedelijk Museum; *Composition* New York, Sidney Janis Gallery; *Composition with Red, Black and White* New York, C. von Wiegand collection; *Composition with Yellow and Blue* Paris, Mary Callery collection

1932 *Composition with Blue and Yellow* Philadelphia Museum of Art; *Composition A* Zurich, E. Friedrich-Zetzler collection; *Composition B with Grey and Yellow* Basel, Müller-Widmann collection; *Composition D with Red, Yellow and Blue* Zurich, Max Bill collection; *Black Lines on White Ground* collection unknown;

Composition with Double Line Basel, Beyeler collection

1932–6 *Composition* collection unknown

1933 *Composition with Yellow Lines* The Hague, Gemeentemuseum; *Composition with Blue and Red* New York, Sidney Janis Gallery; *Composition with Coloured Square* Chicago Art Institute; *Composition with Yellow and Blue* Amsterdam, B. Merkelbach collection; *Composition with Yellow and Blue* Basel, Müller Widmann collection

1935 *Composition* New York, Holtzman collection; *Composition with Red, Blue and Yellow* Basil Gray collection; *Composition with Blue* Birmingham (U.S.A.), H. Lewis Winston collection; *Composition B with Red* Helen Sutherland collection; *Composition* collection unknown

1935–42 *Composition with Red, Yellow and Blue* New York, Holtzman collection; *Composition* Meriden, Burton Tremaine collection; *Rhythms and Black Lines* Radenor H. Clifford collection

1936 *Composition with Red and Black* New York, Museum of Modern Art; *Composition* Philadelphia Museum of Art; *Composition III; Blue and Yellow* Basel, Museum; *Composition with Blue and Yellow* New York, Holtzman collection; *Composition with Blue and White* New York, Holtzman collection; *Composition with Red and Black* New York, Sidney Janis Gallery; *Composition with Red and Blue* Indianapolis, Witzinger collection; *Composition with Red* J. L. and Sadie Martin collection

1936–42 *Composition* collection unknown; *Composition II with Blue* New York, Holtzman collection

1936–43 *Composition with Red, Yellow and Blue* New York, Holtzman collection

1936–44 *Composition with Yellow* (unfinished) New York, Holtzman collection

1937 *Composition with Red and Yellow* Philadelphia Museum of Art; *Composition with Red and Blue* Ben Nicholson and Barbara Hepworth collection; *Composition with Blue* London, Marcus Brumwell collection; *Composition with Red and Black* collection unknown; *Composition* collection unknown; *Composition with Blue and Yellow* collection unknown; *Composition with Yellow, Blue and White* collection unknown

1937–42 *Composition No. 7* collection unknown

1938 *Composition* (unfinished) New York, Holtzman collection; *Composition* New York, Holtzman collection; *Composition with Blue* (unfinished) The Hague, Nieuwenhuizen Segaar Gallery

1938–43 *Place de la Concorde* New York, Holtzman collection; *Composition with Yellow and Red* New York, Holtzman collection

1938–44 *Unfinished Composition* New York, Holtzman collection; *Unfinished Composition with Red* New York, Holtzman collection

1939 *Composition with Red* New York, Holtzman collection; *Composition with Red* Venice, P. Guggenheim collection

1939–41 *Composition with Red and Blue* New York, A. P. Bartos collection

1939–42 *Composition with Red and Blue* New York, Holtzman collection; *Composition with Red, Yellow and Blue* New York, Donald Ogden Stewart collection; *Composition with Black, White and Red* collection unknown

1939–43 *Trafalgar Square* New York, John L. Senior jr. collection

1939–44 *Unfinished Composition* New York, Holtzman collection; collage, New York, Holtzman collection; *Unfinished Composition with Blue, Yellow and Red* New York, Holtzman collection; *Unfinished Composition with Red, Yellow and Blue* New York, Holtzman collection

1941–2 *New York* New York, private collection

1942 *Self-portrait* New York, Holtzman collection; *New York City* New York, Holtzman collection; *New York City No. 2* (unfinished) New York, Holtzman collection; *New York City No. 3* (unfinished) New York, Holtzman collection; study for *Broadway Boogie-Woogie* New York, Holtzman collection

1942–3 *Broadway Boogie-Woogie* New York, Museum of Modern Art

1943 *Composition in a Square with Red Corner* New York, J. J. Sweeney collection; study for *Victory Boogie-Woogie* New York, Holtzman collection

1943–4 *Victory Boogie-Woogie* (unfinished) Meriden, Burton Tremaine collection

Bibliography

WRITINGS BY MONDRIAN

De nieuwe beelding in de schilderkunst (eleven articles), *De Stijl*, 1917–18; *Het bepaalde en het onbepaalde*, *De Stijl*, 1918; *Dialoog over de nieuwe beelding* (two articles), *De Stijl*, 1919; *Natuurlijke en abstracte realiteit* (thirteen articles), *De Stijl*, 1919–20; *De boulevard*, *De nieuwe Amsterdammer*, n. 272, 27 March 1920; *Le Néo-plasticisme*, *L'Effort Moderne*, Paris, 1920; *De bruiteurs futuristes en het nieuwe in de muziek*, *De Stijl*, 1921; *Het Neoplasticisme (de nieuwe beelding) en zijn (hare) realiseering in de muziek*, *De Stijl*, 1921; *De realiseering van het Neo-plasticisme in verre toekomst en in de huidige architectuur*, *De Stijl*, 1921; *Schilderkunst*, *De Stijl*, 1922; *La manifestation du Néo-plasticisme dans la musique et les bruiteurs Italiens*, *La vie des lettres et des arts*, Paris, 1922; *Le Néo-plasticisme, sa réalisation dans la musique et au théâtre future*, *La vie des lettres et des arts*, Paris, 1922; *Die neue Gestaltung in der Musik und die futuristischen Italienischen Bruitisten*, *De Stijl*, 1923; *Moet de schilderkunst minderwaardig zijn aan de bouwkunst?*, *De Stijl*, 1923; *Les arts et la beauté de notre ambiance tangible*, *Manomètre*, Lyons, 1924; *Geen axioma maar beeldend principe*, *De Stijl*, 1924; *De huif naar den wind*, *De Stijl*, 1924; *Die neue Gestaltung*, *Bauhaus-bücher*, Munich, 1925; *De jazz en de néo-plastiek*, *i 10*, Amsterdam, 1927; *Néo-plasticisme*, *i 10*, Amsterdam, 1927; *Ne pas s'occuper de la forme . . .*, *Cercle et Carré*, n. 1, Paris, 1930; *L'art réaliste et l'art superréaliste (la morphoplastique et la né-plastique)*, *Cercle et Carré*, no. 2, Paris, 1930; *Répose de Piet Mondrian*, *Cahiers d'Art*, Paris, 1931; *Note by Piet Mondrian in the last number of De Stijl*, January 1932; *Notes by Piet Mondrian in the albums of the Abstraction-Création group*, n. 1 (1932), n. 2 (1933), n. 3 (1934); *Plastic art and pure plastic art*, *Cercle*, London, 1937; *Kunst zonder onderwerp*, Stedelijk Museum, Amsterdam, 1938; *Toward the true vision of reality*, Valentine Gallery, New York, 1942; *Pure plastic art*, New York, 1942; *Abstract art*, *Art of this century*, New York, 1942; *Plastic art and pure plastic art* (six essays written in English), Wittenborn, New York, 1945 (third edition, 1951); *A new realism*, *American Abstract Artists*, New York, 1946; *Pure beelding*, Stedelijk Museum, Amsterdam, 1946; *Lebenserinnerungen und Gedanken über die Neue Gestaltung*, Kunsthalle, Basel, 1947.

WORKS ON MONDRIAN

G. W. KNAP, *Cornelis Spoor, Piet Mondrian, Jan Sluyters*, De Kunst, Amsterdam, 1909; FREDERICK VAN EEDEN, *Gezonheid en verval in kunst*, Op de hoogte, Amsterdam, 1909; A. SAALBORN, *Piet Mondriaan en anderen*, De Kunst, Amsterdam, 1911; G. APOLLINAIRE, *A travers le Salon des Indépendants*, Montjoie, Paris, 1913; A. SALMON, *Le XXX Salon des Indépendants*, Montjoie, Paris, 1914; N. H. WOLF, *Petrus Alma, Le Fauconnier, Piet Mondriaan*, De Kunst, Amsterdam, 1914; A. O. (AUGUST DE MEESTER-OBREEN) *Piet Mondriaan*, De Kunst, Amsterdam, 1915; T. VAN DOESBURG, *Moderne Kunst, Eenheid*, Amsterdam, 1915; T. VAN DOESBURG, *De nieuwe beweging in de Schilderkunst*, Technische Boekhandel, Delft, 1917; T. VAN DOESBURG, *Aanteekeningen bij twee teekeningen van Piet Mondriaan*, De Stijl, 1918; T. VAN DOESBURG, *Drie voordrachten over de nieuwe beeldende kunst*, Handboekjes elk 't beste, Amsterdam, 1919; J. PEETERS, *Gemeenschapskunst*, Het Overzicht, Antwerp, December 1921; J. PEETERS, *Inleiding tot de moderne plastiek*, Het Overzicht, Antwerp, September, 1922, C.V., *Piet Mondriaan in den Hollandschen kunstrung*, Elsevier, Amsterdam, 1922; T. VAN DOESBURG, *Documentaire*, De Stijl, December, 1922; F. M. HUEBNER, *Die neue Malerei in Holland*, Leipzig, 1921; F. BERCKELAERS (M. SEUPHOR), *Over kunst in 12 punt*, Het Overzicht, Antwerp, January 1924; H. HANNA, *Piet Mondriaan, de pioneer*, Wil en Weg, Amsterdam, May and June 1924; ARP and LISSITSKY, *Les Ismes de l'art*, Zürich, 1925; H. KRÖLLER-MÜLLER, *Die Entwicklung der modernen Malerei* Leipzig, 1925; K. S. DREIER, *Modern Art*, New York, 1926; G. VANTONGERLOO, *L'art plastique (L2) = (S) néo-plasticisme*, Vouloir, Lille, 1926; N. VAN LOON, *Piet Mondriaan, de mensch, de kunstenaar*, Maandblad voor beeldende kunsten, Amsterdam, 1927; Three stage-sets by Mondrian for *L'Ephémère est éternel* reproduced in *Documents Internationaux de l'Esprit Nouveau* I, Paris, 1927; A. SARTORIS, *Elementarismo*, Belvedere, Milan, May–June 1930; M. SEUPHOR, *Greco*, Les Tendances Nouvelles, Paris, 1931; J. BENDIEN, *Piet Mondriaan 60 jaar*, Elsevier, Amsterdam, 1932; A. SARTORIS, *Gli elementi dell'architettura funzionale*, Milan, 1932; P. FIERENS, *L'art hollandais contemporain*, Le Triangle, Paris, 1933; M. SEUPHOR, *Sartoris. Architecture du sentiment, sentiment d'architecture*, Milan, 1933; J. J. SWEENEY, *Plastic redirection in 20th-century painting*, Chicago, 1934; J. BENDIEN, *Richtingen in de Hedendaagsche schilderkunst*, Amsterdam, 1935; A. H. BARR. *Cubism and Abstract Art*, New York, 1936; A. SARTORIS, *El pintor elementalista Piet Mondrian*, Fabula, La Plata, May–June, 1937; A. SARTORIS, *Mondrian, Origini*, Rome, October, 1937; A. SARTORIS, *Piet Mondrian, Campografico*, Milan, January, 1938; J. TORRES-GARCIA, *Historia de mi vida*, Montevideo, 1939; Catalogue, *Museum of living art*, New York, 1940; S. JANIS, *School of Paris comes to U.S. Decision*, New York, November 1941; M. BILL, *Aaan Piet Mondriaan op zijn 70e verjaardag, 8 en opbouw*, Amsterdam, 1942; H. F. KRAUS, *Mondrian, a great modern Dutch painter*, Knickerbocker Weekly, New York, 1942; C. VON WIEGAND, *The Meaning of Mondrian*, Journal of aesthetics and art criticism, New York, 1943; J. BRADLEY, *Piet Mondrian, 1872–1944, greatest Dutch painter of our time*, Knickerbocker Weekly, New York, 1944; J. J. SWEENEY, *Piet Mondrian*, The Museum of Modern Art Bulletin, New York, 1945 (reprinted together with an interview with Mondrian in 1948); *In memoriam Mondrian en Kandinsky*, De groene Amsterdammer, Amsterdam, 1945; S. JANIS, *Abstract and Surrealist Art in America*, New York, 1944; J. TORRES GARCIA, *Universalismo constructivo*, Buenos-Aires, 1944; Interview with Harry Holtzman, *New Yorker*, 15 April, 1944; S. JANIS, *Notes on Piet Mondrian, Arts and Architecture*, New York, January 1945; *Speaking of Pictures . . . this is art by Piet Mondrian*, Life, July 1945; S. CHERMAYEEF, *Mondrian of the perfectionnists, Art News*, New York, March 1945; P. LOEB, *Voyages à traverse la peinture*, Paris, 1946; P. ALMA, T. BRUGMAN, C. VAN EESTEREN, J. J. P. OUD and M. SEUPHOR, *Piet Mondrian Herdenkingstentoonstelling*, Amsterdam, 1946; M. SEUPHOR, *Piet Mondrian – Réflexions et souvenirs*, Basel, 1947, L. MOHOLY-NAGY, *Vision in Motion*, Chicago, 1947; C. BIEDERMAN, *Art as the evolution of visual knowledge*, Minnesota, 1948; H. R. HITCHCOCK, *Painting toward architecture*, New York, 1948; H. READ, *Constructivism: the art of Naum Gabo and Antoine Pevsner*, New York, 1948; M. SEUPHOR, *Catalogue de Matisse à Miro*, Alès, 1948; J. J. SWEENEY, *Piet Mondrian*, New York, 1948; M. SEUPHOR, *L'art abstrait, ses origines, ses premiers maîtres*, Paris, 1949, new edition 1950; A. LEEPA, *The Challenge of Modern Art*, New York, 1949; P. LOEB, *Regards sur la Peinture*, Paris, 1950; L. MOHOLY-NAGY, *The New Vision*, New York, 1949; M. SEUPHOR, *Piet Mondrian et les origines du néo-plasticisme, Art d'Aujourd'hui*, Paris, December, 1949; M. SEUPHOR, *Suprématisme et néo-plasticisme, Art d'Aujour-d'hui*, Paris, March 1950; A. M. HAMMACHER, *New York–Rembrandt–Mondrian, De groene Amsterdammer*, Amsterdam, December 1949; A. M. HAMMACHER, *Piet Mondrian 1872–1944, Kroniek van kunst en kultuur*, VIII, 9. 1949; *Collection of the Societé Anonyme*, New Haven (Connecticut), 1950; M. RAYNAL, *De Picasso au surréalisme*, Paris–Geneva, 1950; T. N. HESS, *Introduction to Abstract, Art News annual*, New York, 1951; M. SEUPHOR, *Temps héroïques et survivance de l'art abstrait, Spazio*, Rome, 1951; M. SEUPHOR, *Le Peintre Bart Van der Leck, Werk*, Zürich, November 1951; J. J. SWEENEY, *Mondrian, the Dutch and De Stijl, Art news*; New York, summer 1951; A. W. LEVI, *Mondrian as metaphysician, The Kenyon review*, Ohio, summer 1951; L. DEGAND and M. SEUPHOR, *L'exposition De Stijl, Art d'Aujour-d'hui*, Paris October 1951; C. BIEDERMAN, *Letters on the new art*, Minnesota, 1951; A. C. RITCHIE, *Abstract painting and sculpture in America*, New York; T. B. HESS, *Abstract Painting – Background and American phase*, New York, 1951; VORDEMBERGE-GILDEWART, *Zur Geschichte der Stilj-Bewegung, Werk*, Zürich, November 1951; M. SEUPHOR, *Histoire sommaire du tableau-poème, XXeme siècle*, Paris, June 1952; M. SEUPHOR, *Piet Mondrian – 1914–1918, Magazine of Art*, New York, May 1952; M. SEUPHOR, *Théo van Doesburg, Art d'Aujourd'hui*, Paris, December 1953; M. SEUPHOR, *Le premier séjour de Piet Mondrian à Paris, Preuves*, Paris, October 1953; *De Stijl, The Museum of Modern Art bulletin*, vol. XX, 2, winter 1952–53; J. FITZSIMMONS, *Modern surveys of Stijl; its contribution to design, Art Digest*, January 1953; T. B. HESS, *The Dutch: this century, Art News*, New York, January 1953; B. ZEVI, *Poetica dell'architettura neoplastica*, Milan, 1953; M. SEUPHOR, *Mondrian peintre figuratif, XXeme siecle*, 4, Paris, 1954; M. SEUPHOR, *Mondrian indésirable, Art d'Aujourd'hui*, Paris, February 1954; *Dizionario della pittura moderna* (entries on Mondrian, van Doesburg, De Stijl, Neoplasticism), Milan, 1959; A. H. BARR, *Masters of Modern Art*, New York, 1954; M. SEUPHOR, *The neglect of Mondrian, Art Digest*, 15 February 1954; H. L. C. JAFFE, *De Stijl, Art d'Aujourd'hui*, May–June 1954; M. SEUPHOR, *La Synthèse des arts: est-il possible? Art d'Aujourd'hui*, May–June 1954; M. SEUPHOR, *Humanisme de Mondrian, Aujourd'hui*, 2, Paris, 1955; M. SEUPHOR, *Introduction to Construction No. 2*, Lausanne, 1955; H. L. C. JAFFE, preface to the catalogue of the Mondrian Exhibition at the Whitechapel Gallery, London, 1955; L. J. F. WIJSENBEEK and M. SEUPHOR, preface to the catalogue of the Mondrian retrospective at the Gemeentemuseum, The Hague, 1955; M. BILL and M. SEUPHOR, preface to the catalogue of the Mondrian retrospective at the Kunsthaus di Zurich, 1955; A. M. HAMMACHER, *Stromingen en persoonlijkheden*, Amsterdam, 1955; J. BLOM, *Van Piet Mondrian tot P. M.*, Ivio, Amsterdam, 1955; M. SEUPHOR, *Piet Mondrian, sa vie, son oeuvre*, Paris, 1956, Italian edition, Milan, 1958; O. MORISANI, *L'astrattismo di Piet Mondrian*, Venice, 1956; W. SANDBERG, preface to the Mondrian retrospective in the catalogue of the Venice Biennale, 1956; H. L. C. JAFFE, *De Stijl, 1917–1931*, Amsterdam, 1956; M. SEUPHOR, *De Stijl, L'Oeil*, Paris, October 1956; W. SANDBERG, *Piet Mondrian, Quadrum n. 2*, Brussels, 1956; M. SEUPHOR, *Dictionnaire de la peinture abstraite*, Paris, 1957; *The World of Abstract Art*, New York, 1957; M. BILL, *Piet Mondrian, Nueva Vision No. 9*, Buenos-Aires, 1957; D. LEWIS, *Mondrian*, London, 1957; M. SEUPHOR, *Piet Mondrian et le nouveau réalisme, XXème Siècle*, 9 Paris, 1957; C. HOLTY, *Mondrian in New York: a memoir*, Arts, New York, September, 1957; M. JAMES, *The realism behind Mondrian's geometry, Art News*, New York, December 1957; M. SEUPHOR, *Mondrian*, Paris, 1958; D. SURO, *L'espace: Mondrian et Picasso, Aujourd'hui*, 20, Paris, 1958; S. HUNTER, *Mondrian*, New York, 1958; W. HAFTMANN, *La pittura nel XX secolo*, Milan, 1960; M. SEUPHOR, *Sens et permanence de la peinture construite, Quadrum*, 1960; M. BUTOR, *Le Carré et son habitant, Nouvelle revue Française*, Paris, January–February 1961; M. SEUPHOR, *La peinture abstraite, sa genèse, son expansion*, Paris, 1962; C. L. RAGGHIANTI, *Mondrian*, Milan, 1962; F. MENNA, *Mondrian, cultura e poesia*, Rome, 1962; M. SEUPHOR, *Mondrian*, article in *Enciclopedia Universale dell'Arte*, IX, Venice-Rome, 1963; M. SEUPHOR, *Mondrian et la pensée de Schoenmae-kers, Werk* 9, Winterthur, 1966; R. P. WELSH, *Piet Mondrian*, Toronto, 1966; *Dictionnaire universel de l'art et des artistes*, Paris, 1967; D. VALLIER, *L'art abstrait*, Paris, 1967; G. RICKEY, *Constructivism, Origins and Evolution*, New York, 1967; H. L. C. JAFFE, *Piet Mondrian*, Recklinghausen, 1968; A. BUSIGNANI, *Mondrian*, Florence 1968; *Mondrian* (catalogue of the exhibition of the works of Mondrian at the Orangerie des Tuileries), Paris, 1969